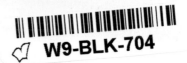
THE PHOTOGRAPHER'S GUIDE TO USING
FILTERS

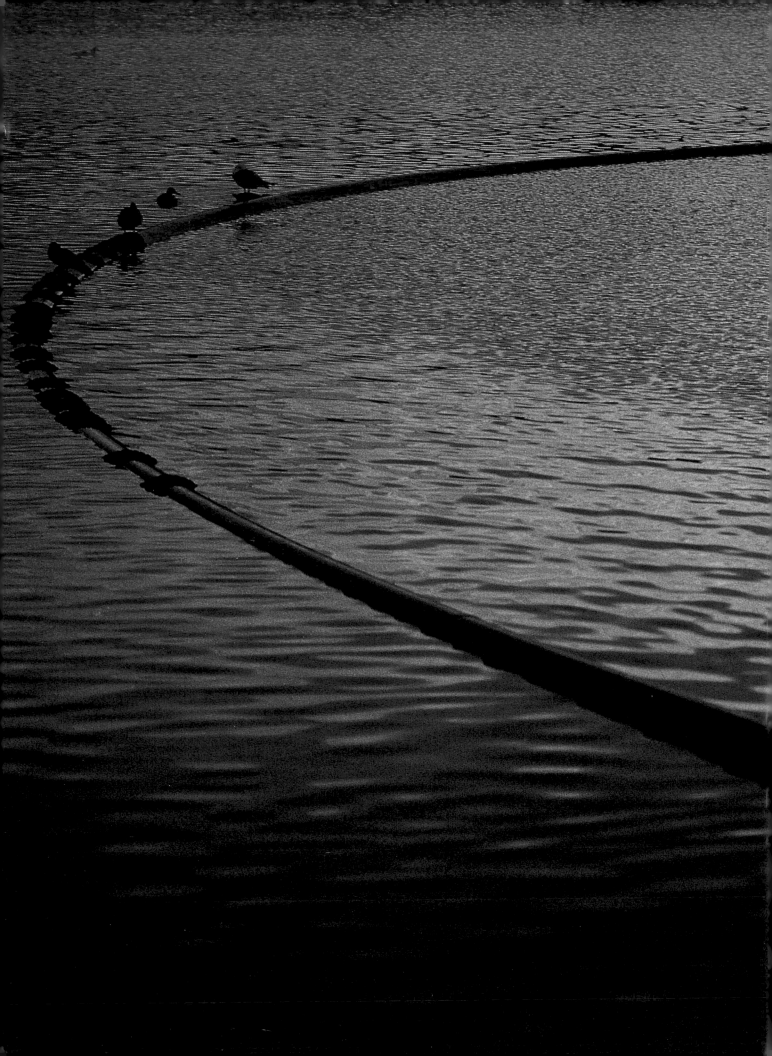

THE PHOTOGRAPHER'S GUIDE TO USING

FILTERS

REVISED AND UPDATED

JOSEPH MEEHAN

AMPHOTO BOOKS
AN IMPRINT OF WATSON-GUPTILL PUBLICATIONS/NEW YORK

Joseph Meehan is a contributing editor to *Petersen's Photographic* and also writes for the *British Journal of Photography, Industrial Photography*, and *Photo District News*. A former professor in the State University of New York system, Meehan has also taught photography courses at the School of Art, Ealing College, London, and the National Taiwan Academy of Art, Republic of China. His photographs have appeared in many books and magazines in the United States, Europe, and Asia. He is the author of *Panoramic Photography* (Amphoto, 1990) and *The Complete Book of Photographic Lenses* (Amphoto, 1991).

ACKNOWLEDGEMENTS

I would like to thank Ingeborg X. Grutzner and Amphoto editor Liz Harvey for all their help in the preparation of the final manuscript. I would also like to thank Viron Barbay, Frank Cricchio, John Denver, Harrison Northcutt, and Mike Stensvold for the use of their images.

First published in New York by AMPHOTO,
an imprint of Watson-Guptill Publications,
a division of BPI Communications, Inc.,
1515 Broadway, New York, NY 10036

Library of Congress Cataloging-in-Publication Data

Meehan, Joseph.
 The photographer's guide to using filters / by Joseph Meehan. —
Rev. ed.
 p. cm.
 Includes index.
 ISBN 0-8174-5452-7 (paper)
 1. Photography—Light filters—Handbooks, manuals, etc.
I. Title.
TR590.5.M44 1998
771.3'56—dc21 98-11624
 CIP

Manufactured in Malaysia

1 2 3 4 5 6 7 8 9 / 06 05 04 03 02 01 00 99 98

Editorial concept by Robin Simmen
Edited by Liz Harvey
Graphic production by Ellen Greene

TO LYNN—FOR SQUIRE HILL,
CHRISTCHURCH, FRITZ,
AND ALL THE REST

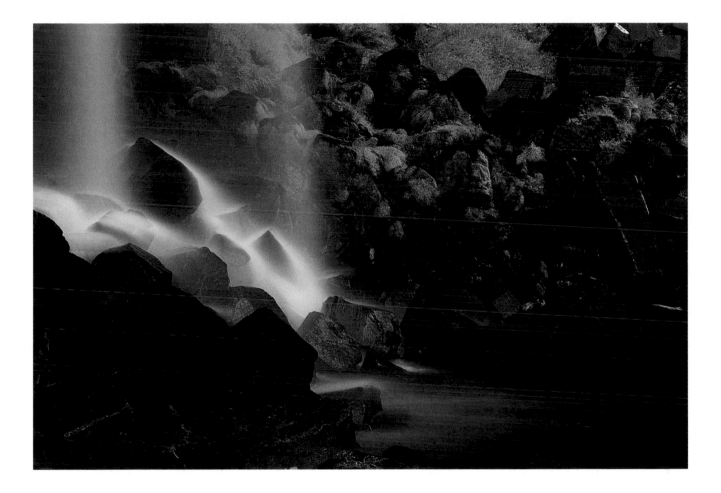

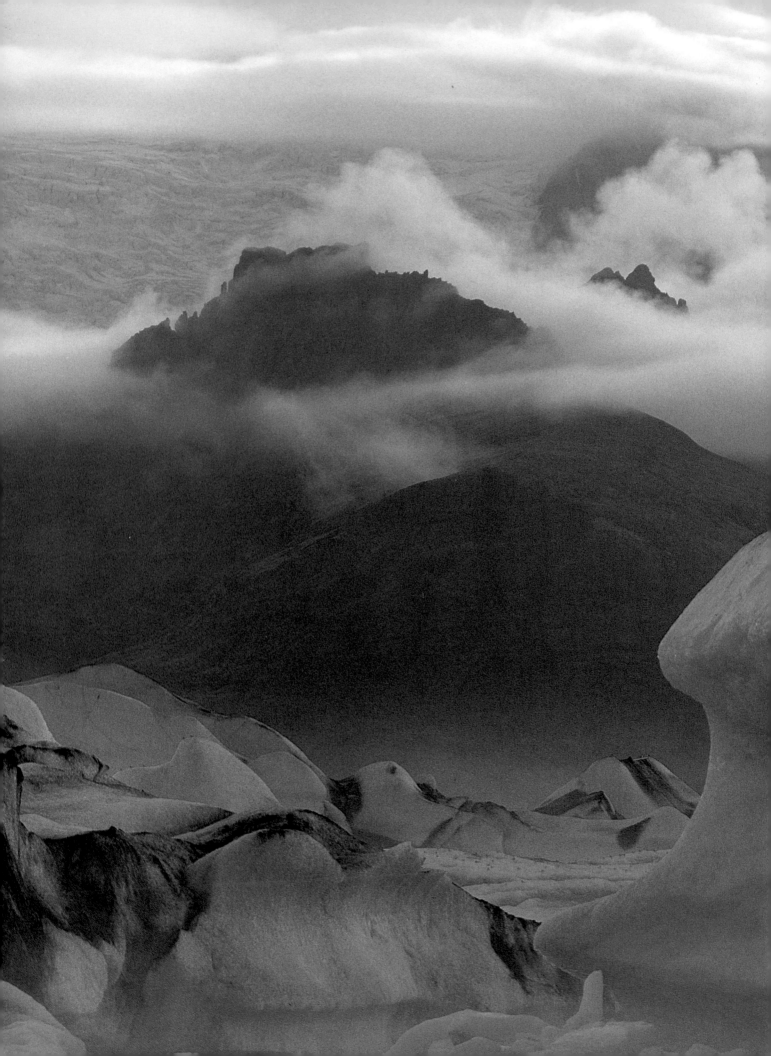

CONTENTS

INTRODUCTION

I use filters in one form or another for the vast majority of my work, and have done so for the past 25 years. Why? Because they enable me to take pictures with more satisfying results. Filters are as essential to me as the film and the type of lens I use. Yet, for many photographers, filters are seen as some form of cheating, of making natural settings unnatural and, therefore, invalid. Needless to say, this perception has always been an enigma to me.

If you think about it, photographers are continually manipulating the photographic process, from the selection of a particular lens to narrow or widen the view, to the selection of a particular film that gives more or less grain, and deeper or subdued colors. Then, too, studio photographers direct light from small, powerful sources into desired configurations by using reflectors and diffusers. And in the darkroom, photographers continue the manipulative process to add or subtract light in order to change the overall appearance of a print or just specific parts of one, as in burning in and dodging out.

Photographers go to all this trouble for two reasons. They need to correct for inadequacies in the materials that are being used, and they want to create a final image that has something they want in it. These processes aren't necessarily mutually exclusive, of course, but they're driven by different motivations. In correction there is most often the need to document reality by having the materials perform as closely to their theoretical potential as possible. In creativity the rules of correctness are more likely to be bent, if not broken, because photographers are looking for something different from reality.

Where, then, do filters fit in all this? The answer is, in both areas. Filters are in fact nothing more than another way for photographers to deal with the physical components of their craft. The target of filters is light, and the role of filters is either to change its color content or to alter its behavior in terms of focus, reflection, direction, or intensity. As such filters fall into two major categories: chromatic (colored) and nonchromatic (colorless). In both forms their primary functions are to correct for deficiencies in light and film, to create impressions through exaggerations, or even to form their own impact by introducing elements not in the original scene. To effectively use filters then, like most other photographic materials, you have to know something about what they're affecting, that is, light and film.

Although most photographers are familiar with the concept of filtration, very often their knowledge is rooted in practical but limited procedures. How many times have you heard comments like "A red filter increases contrast in a black-and-white print" or "The skin tone was warmed up a bit with a filter"? What do these pronouncements really mean? The answer is that photographers use filters to change the light reaching the film in some specific way. So that should mean that they have an understanding of both the characteristics of light and the function of the filter. All too often, however, it simply means that the photographers follow a certain method because they had success with it in the past. This limited approach stifles any creative photographer. That is why regarding the use of filters as a form of cheating is not only incorrect, but also reflects a lack of knowledge about their role and the nature of photographic procedures in general.

Filters are an exciting alternative to accepting the vicissitudes of light and environmental conditions and the specific deficiencies of photographic film. In addition, filters represent an almost limitless mechanism for individual expression through their ability to reshape reality. The extent to which photographers can use filters for correction or creativity depends in part on their knowledge of light and film as well as the filter's role. The rest is up to the photographers and their willingness to experiment.

This book is organized in three parts. The first section addresses: the essentials of light, its composition and behavior; the essentials of film, its makeup and

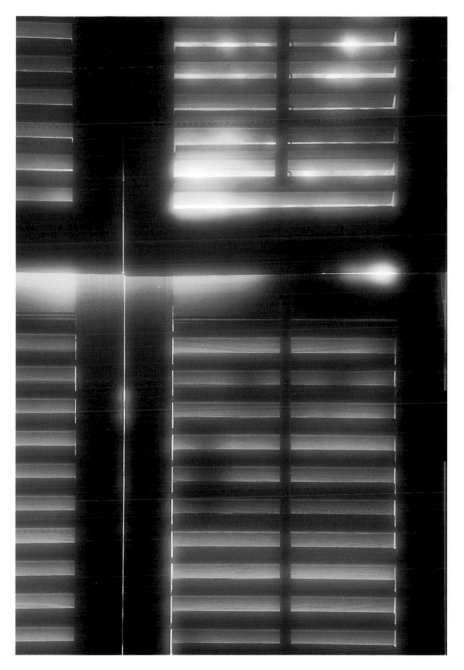

Filters are used to manage the physical characteristics of light, most commonly by altering its color content. But filters can also change the contrast of light or the focus point on film via such processes as diffusion or diffraction, which is caused by, for example, star patterns and repeated images.

response to light; and the basics of how filters work. The second part applies these principles to chromatic filters and how they affect light and, subsequently, film within specific picture-taking situations. The remaining section shows how nonchromatic filters can be used to affect images and examines special-effect filters and their uses. Throughout the book I emphasize two themes—correction and creativity—so that you can see how filters are used in the conventional sense, as well as how they can be used for a more personal interpretation. The running text explains the principles and procedures that substantiate this dual role of filters, while charts and figures supply fundamental data as well as specific filter recommendations. So the

book can serve as a quick reference guide for future use once you've taken the time to learn the essentials.

My goal in writing this book is to present honestly and completely a subject that has too often been organized along narrow limits. I think filters are an open-ended opportunity for photographers to expand their view of the world. Moreover, learning how to use filters teaches you so much about the other aspects of photography that you're always gaining insights into the whole photographic process. If you consider the path of light from source to subject to film, your last chance to manipulate the unexposed image comes with camera filters. In many ways, I believe this is an excellent illustration of the adage, "saving the best for last."

PROPERTIES OF LIGHT AND FILM

Photography is part art and part science. No doubt this dual heritage explains the wide range of people who are attracted to the field and its diverse applications. Some photographers are more comfortable with the technical aspects of making photographs, while others are drawn to the aesthetic qualities. As such many people become polarized at one of these two extremes,

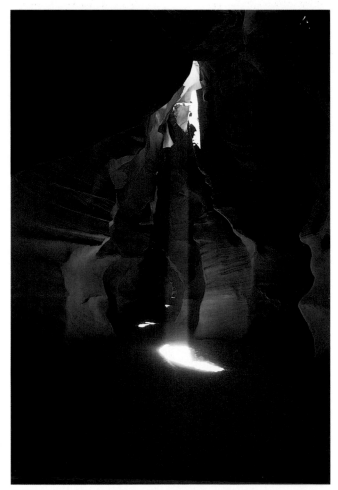

This full-contrast subject has highlights, the brightest parts of an image where you can clearly see details; shadows, the darkest areas where detail is clearly visible; and midtones, which contain the strongest renderings of color.

and their approaches are strongly influenced by their orientations. Regarding either attitude as sacrosanct is counterproductive when learning about filters.

The fact is, to exploit the full potential of filters you should have an understanding of the technical and an appreciation for the aesthetic basis of their use. Then you'll be able not only to use filters "correctly," but also to have access to more creative possibilities in photographic expression. The key, then, is to build a solid base of facts about the physical properties of light, film, and the effect of filters while acquiring, through experimentation and experience, an appreciation of how they work together to produce a pleasing aesthetic impression.

HOW PHOTOGRAPHERS THINK ABOUT LIGHT

Photography is based on light's ability to strike an object, reflect off it, and be focused onto a piece of film. The appearance of the subject on film results from that reflection being transformed into different areas of brightness and color. In black-and-white photography the colors are "translated" into tones of gray as well as black and white. Without variations in brightness, as in areas of light and shadow, you wouldn't be able to detect shapes, forms, and textures, and without tones and/or color you would know very little about the physical composition of the subject itself.

Photographers know that how the subject looks on film is influenced, if not dictated, by many qualities of the light itself, as well as by what happens to it on its path from the source to the subject and then to the film. Consider, for example, the physical makeup of the light source. Is it bright and focused, such as a spotlight on stage, or is it spread out, such as a ceiling full of fluorescent tubes? Does the light strike the subject directly, or is there something between the subject and the source, as in the frosted glass of a skylight? Is the light coming directly toward the subject from behind

Light is both the language of photography and the medium for filters. Various filter effects, such as these strong colors produced by combining certain chromatic filters, are successful when they evoke an emotional response in viewers.

the camera or at a sharp angle to it? The more you are aware of these variables and how they operate, the more likely you'll be able to control the final image with filters, leaving less to chance and luck.

Take, for example, a situation in which you're shooting on a heavily overcast day. Your model might summarize the physical conditions under which the picture is being taken as "gloomy." You, on the other hand, should be aware of the flat contrasts from the very even light source, which has a preponderance of blue. Furthermore, the low level of light probably calls for film that renders color brightly and a tripod. So the word "gloomy" sums up quite a number of considerations. Yet in the end, this term might be a better indication of the photograph's lasting impression because it reveals something about the mood.

The point is that photographers must work in the physical and the emotional world simultaneously and understand how the two relate. Most viewers look at a picture for a visual experience, not to see what happens when an 80C warming filter is combined with a diffusion screen. As a matter of fact, you might spoil their reaction by saying, "I did it with filters," as if that represented a form of deception—despite the fact that the warming and diffusing effect mimicked by your filters occurs around sunset on most hot, hazy days.

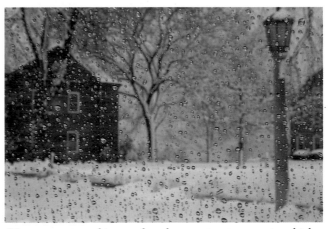

Heavy, overcast skies produce low-contrast scenes in which the brightness range of subject matter is limited and colors are muted. In this shot, taken through a rain-splattered window, the bright red building appears maroon and the white snow is a dreamy light gray.

Any effective method of dealing with light and filters has to account for several variables: the source of the light, whether or not the light is affected by a *light modifier* before it reaches the camera, and the physical makeup of the subject itself. As a prerequisite for filter selection and use, you need to look at each of these conditions individually and, in the process, develop a method for analyzing the effects of light.

LIGHT SOURCES AND THEIR EFFECTS

Photographers generally use one of four light sources: natural light from the sun, electronic flash, studio tungsten bulbs, or quartz bulbs. These differ in many ways, but they all share certain physical characteristics in relation to the subject—specifically, their size and direction. Regardless of the light source, the following generalizations apply.

SIZE AND DIRECTION OF LIGHT SOURCE

As a source of light becomes smaller, the shadows it casts become stronger and more defined. Photographs made under bright sunlight or with a small, on-camera flash or a spotlight on stage typically show dark, sharply defined shadows. This is because all of the light comes from one small, narrow point and hits the subject at almost the same angle, thereby directing its illumination only at that portion of the subject facing the light and casting the rest in dark shadow. This effect is even more pronounced when the light is set at an extreme angle to the subject; in this situation some of the shadows are cast across the subject as well as behind it. Think, for example, of the shadow a person's nose casts when the face is sidelit.

On the other hand, if the light source is larger than the subject, the light comes at the subject from a wide range of angles. Imagine the sun's illumination reflecting off the ground into large office windows, or a large, white ceiling bouncing back an electronic flash. A more diffused light source allows the light to penetrate shadow areas, reducing their size and softening their edges. Finally, if the light source is so large that it is evenly distributed over the whole

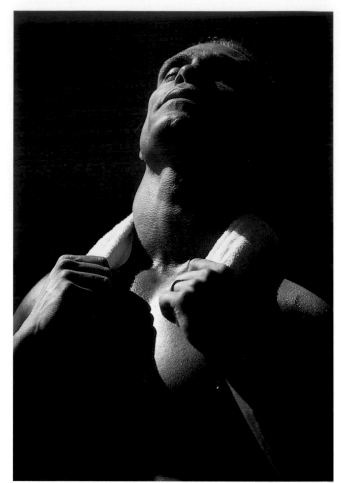

Hard light, such as direct sunlight, characteristically produces strong shadows, bright highlights, and sharp delineations between light and dark areas.

sky, as on an overcast day, the lighting will be almost shadowless because virtually all the shadows will be filled in.

SHADOWS VERSUS HIGHLIGHTS

Photographers often use a method of evaluating light by defining three subject areas of illumination and determining the light's effect on them: the *shadows,* or darkest areas; the *highlights,* or brightest areas in the most direct light; and the *midtones,* or the areas that fall in between, or simply the middle area. In general, small light sources produce very sharp points of delineation between the highlight, middle, and shadow areas. Furthermore, there is a very wide range of brightness from highlight to shadow—so much so in fact that the film may not have the latitude to record the whole range.

As the source becomes larger the borders between these areas soften, and the brightness range generally decreases; this makes it easier to record the light on film. The overall aesthetic result is that small light

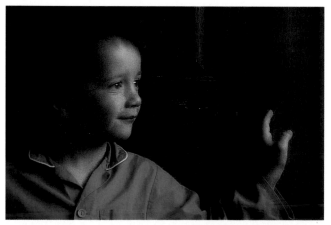

Studio photographers favor the medium light of such devices as umbrellas, diffusion screens, and soft boxes in order to produce just enough shadow to mold the features. Professionals also use a soft-focus filter to provide some minor softening of detail in portraits, as shown here.

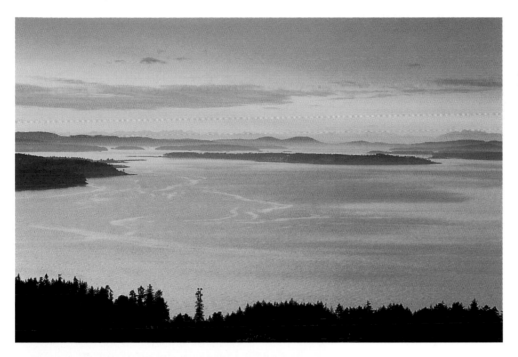

Natural light changes in color and contrast during the course of the day, from the high-contrast sunlight at midday, when all colors are present in roughly equal amounts, to the low-contrast, cool blue-violet colors that appear after sunset, as shown in this shot of the San Juan Islands, Washington.

Natural light is made up of two main sources, the sun and the reflected light of the sky. Each of these sources changes its color content and contrast according to weather conditions and the time of day. So, as shown here, near sunset on a clear day it is possible to have both very warm yellow sunlight and cool blue sky light striking a subject.

sources make a scene appear harshly illuminated, while a very large light causes flat effects. A medium light casts just enough shadows to give the object shape and form, and at the same time enlarges the middle areas where the light on the subject is neither too strong nor too weak. Typical medium-light sources are windows, skylights, and studio flash in umbrellas or lightboxes. All of these are popular because they render a balanced effect with a gradual zone of transition in between the three areas.

CONTRAST

The term *contrast* describes many situations in photography, all based on some sort of perceived difference. In black-and-white negatives contrast may refer to the absolute difference in light that passes through the highlight and shadow areas of a negative as measured by a *densitometer*. With color negatives, contrast may be based on the differences in color hues in a particular scene as measured against some standard with a color meter in the darkroom.

While these categorical examples are very useful, they represent only a quantitative approach. Very often, contrast is an impression of differences caused by conditions that, when measured objectively, don't necessarily support the perception. For example, if you use a *polarizing filter*, or *polarizer*, to remove reflections in a photograph of brightly colored flowers against a clear sky, most observers will conclude that you've increased the contrast because the sky is now a "richer blue" and the colors of the flowers are "deeper." In fact, the absolute differences between the

two have become less than they were without the filter. The contrast between the sky and the flowers only seems greater because the colors of both are stronger (see page 110 for more information about polarizers).

Contrast is as much a relative as an absolute concept, and since filters can change so many of light's attributes, the chances of them influencing perceived contrast are quite extensive. Keeping that in mind, consider some of the ways in which contrast can be affected. In black-and-white photography, the relationships between gray tones as well as between black and white determine a viewer's response to contrast. In the gloomy-day illustration discussed earlier, a preponderance of grays in the final print produced little separation between the picture elements. In other words, objects appeared to merge and lack distinction because only a small portion of the entire gray scale, from pure black through many different tones of gray to pure white, was used. "Gloomy" usually indicates only dark grays and, perhaps, black in a final print, while "flat" or "dull" refers to only light grays and off-white. Conversely, the more tones of the gray scale are included in a picture, the better the contrast.

Normal contrast usually means that highlights fall at the white and light-gray end of the scale, shadows at the dark gray and black end, and midtones across the remaining center. *Shadow detail,* or the first indication of detail in the darkest part of the print, is the first discernible shade of dark gray below black, and *highlight detail* is the first shade of light gray below white. Here, then, light sources or strong reflections are pure white in the print, and areas in which light is completely absent are black.

What, then, is *high contrast?* The answer is, again, an incomplete gray scale. Unlike *low-contrast tones,* high-contrast tones aren't incomplete and close to one another on the scale; instead, they represent extremes in contrast. The frequently used example of coal dust on snow in bright sun pretty much captures the essence of a high-contrast print in which the tones present are few and far apart.

What then about color? To an extent you can think of color contrast in terms of the separation of tones and their range of differences. For example, if you have a scene with various shades of green, such as trees in midsummer, then you run the risk of a low-contrast impression if the shades are too close to each other. On the other hand, that same scene photographed in late spring shows more perceived contrast because new leaves are characteristically lighter than mature ones. So photographs I make during the spring are far more appealing than those shot in the middle of the summer. (Still, springtime images pale in comparison to the incredible color changes that occur in the fall.)

This one example points up the complexity of color contrast because you have to consider at least the following potential influences: variations in shades of one color of leaves, such as light green versus dark green; variations in colors that are close to each other, such as violet versus blue in the sky; as well as colors that are very different, such as a red barn versus a blue sky; and emotional qualities of color, such as cool blue versus warm red.

Black-and-white photographs also show variations in contrast, based on whether or not the light source is soft, as on this overcast day, or hard.

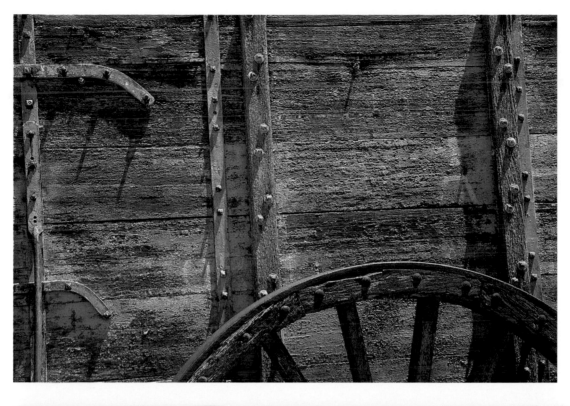

The direction of the light influences the way a subject appears and, in some cases, the effect of a filter. In this picture, the textured wagon is sidelit by the sun. This causes tiny shadows to appear on the wagon's surface, thereby providing more detail in the print.

Color in natural settings tends to be in harmony with variations in hues, such as in green foliage. However, exceptions, such as bright flowers and autumn leaves, stand out against large areas of green.

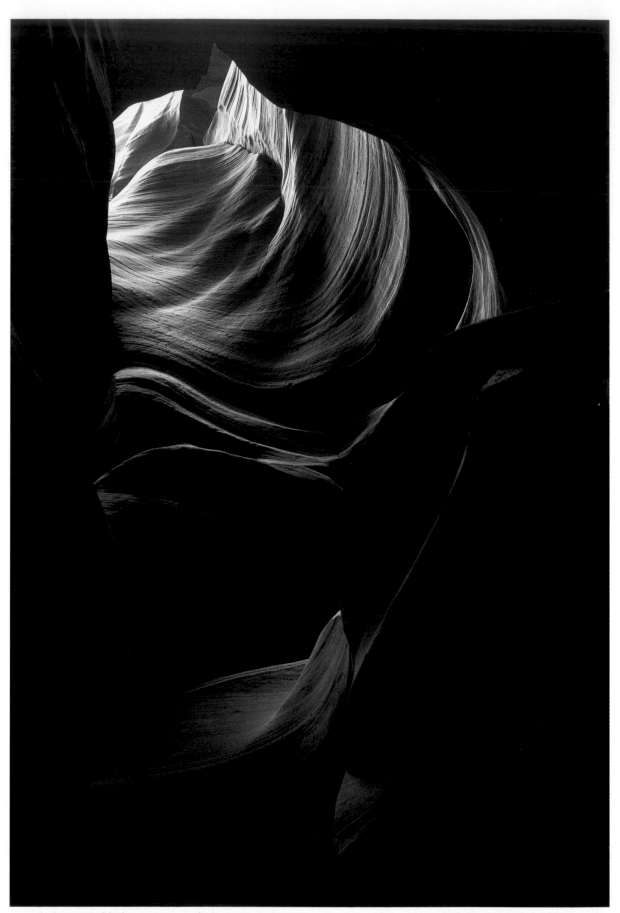

Small, directional light sources produce strong contrasts, as shown in this canyon shaft. I modified the black-and-white quality of the contrast somewhat by using a strong magenta filter.

Don't, however, let this complexity deter you from understanding color contrast. I see it as a marvelous opportunity for experimenting with the variables involved. In fact, this is one of the main reasons I find filters so exciting. They present me with the opportunity to create within this network of influences. I often find myself trying something based on theory, as well as something else simply to see the effect. While this approach sometimes results in disappointment, I'm always learning and discovering relationships between the physical properties of light and their aesthetic impressions that make me appreciate my successful experiments all the more.

COLOR CONTENT OF LIGHT SOURCES

Color, as you perceive it through your eyes, comes from the light of either natural sources, such as the sun or a fire, or artificial illumination, such as electronic flash. All of these sources produce wavelengths of electromagnetic energy that you can see—hence, the term *visible,* or *white, light.* The electromagnetic spectrum contains visible light, along with other energy wavelengths that you can't see. *Ultraviolet (UV) light* falls on one side of the band of white light, and *infrared light* on the other; both are invisible (see Figure 1-1).

Within the spectrum of light that you can see are the so-called *color wavelengths.* Students often use the name "ROY G. BIV" as a mnemonic device to remember the colors and their sequence. This combination of wavelengths in roughly equal proportions gives white light its colorless appearance. The absence of light and color is black.

White light is, therefore, the source of all color in a photograph. Certain *light modifiers,* whether they are environmental, such as pollution, or standardized, such as a filter, can only alter the colors of light by changing the proportion of wavelengths that reach the film through the process of *subtraction.* That is, they all work by *blocking,* or *absorbing,* some of the wavelengths (see page 37). A series of conversion filters, for example, allows different percentages of colors to pass (see Figure 1-2).

FIGURE 1-1. THE ELECTROMAGNETIC SPECTRUM

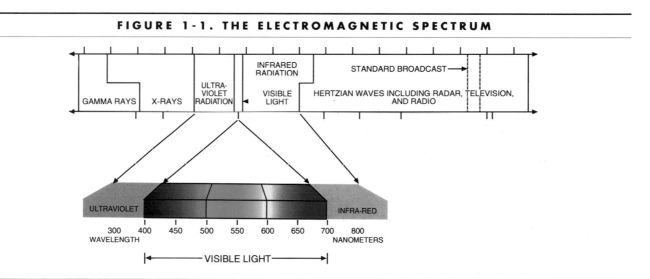

FIGURE 1-2. COLOR WAVELENGTHS OF COMMON LIGHT SOURCES

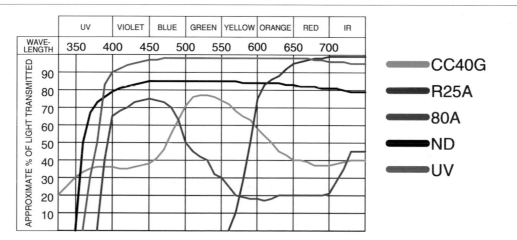

FIGURE 1-3. ADDITIVE AND SUBTRACTIVE PRIMARY COLORS

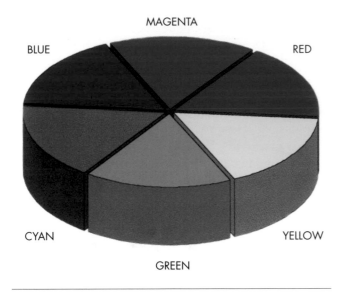

White light is made up of three *primary,* or *basic, colors:* red, green, and blue. When they're combined in various proportions, they produce virtually all other colors. Red, green, and blue are, therefore, called the *additive primaries.* It follows that color from a pure light source, unlike color from one that has been filtered by light modifiers, is the consequence of an additive process. Besides the primary colors of red, green, and blue, there are the *subtractive primaries;* these colors are formed when equal amounts of two of the additive primaries are combined as follows (see Figure 1-3). Mixing blue and green yields cyan, mixing green and red yields yellow, and mixing red and blue yields magenta.

And by mixing an additive primary with a specific subtractive primary, white light is produced. For example, if you combine magenta, the subtractive primary made up of red and blue, with the additive primary of green, its *complementary color,* you'll get white light. In the additive-primary combinations discussed earlier, red is complementary to cyan, and blue is complementary to yellow. So two colors are considered complementary when adding them results in white light. The scale of complementary colors is important because the greatest amount of color a chromatic filter absorbs is its complementary color (see page 37). Furthermore, the two colors that comprise a subtractive primary are also complementary to its additive primary. For example, red and blue, which make up magenta, are complementary to green. Similarly, cyan's components, blue and green, are complementary to red, and yellow's components, red and green, are complementary to blue.

All of these principles apply equally to color film and to colored filters used with black-and-white film because all color is translated to tones of gray in a monochrome emulsion. In addition, the opposing relationship between complementary colors extends to aesthetics because these colors are also the most likely to clash when used together, in fashion for example, unless the clash is the desired effect—the fashion statement.

In photography such a combination depends on the subject matter, although natural settings don't usually have large areas with bright, complementary colors side-by-side. When this happens, however, the effect is quite striking; imagine a field of yellow sunflowers set against a deep blue sky. Most natural scenes are *color harmonized,* as in the various greens of tree leaves and the blues of the sky and the ocean. What makes the difference photographically in harmonized arrangements, then, are variations in *hue,* such as a *tint,* in which a color is part of another color, and/or *saturation,* or pureness, unencumbered by reflections or interference from other colors. Red, for example, can appear in a pure, saturated form, as in a rose, or it can be a tint, as in the red mahogany of a wood table. That same brilliant red rose may also have its color "desaturated" by fog, which dilutes its purity. Here the red becomes pastel. Incidentally you are more likely to tolerate the rose being less sharply focused under these conditions, whereas in bright light lack of sharpness is less acceptable. This is generally true of all color renderings. The more saturated the color, the more sharpness plays a role in the final impression.

You'll find that it is difficult to judge the color content of a light source because you tend to measure physical qualities in a relative manner. But absolute white light is actually more the exception than the rule. In many cases either the red or blue end dominates. For example, you might think that the bright tungsten light of a living room is white until you fire an electronic flash, momentarily bathing the room in a brighter and whiter light. Even when light does have a strong cast, such as the light at sunrise or candlelight, you quickly adapt to it and may use an aesthetic term, such as "soft" or "mellow," to describe it. Similarly, when you see the colors of light split up—in a prism, on a soap bubble, in a rainbow, or at the edge of a pair of glasses—you might initially think of it as some peculiar phenomenon rather than as a reminder of the multicolored nature of light. You

aren't forced to think about the chromatic nature of light until this physical characteristic works against you in a photograph. One typical situation is when you shoot film intended for use in daylight under household lighting and see major color shifts.

Most natural and artificial light sources show their variation in whiteness by larger proportions of either red or blue, that is toward either the warmer or cooler end of the spectrum. A few exceptions are fluorescent light sources, which have a preponderance of green, and sodium-vapor sources, which may not contain all the colors of the spectrum. So you can rate most full-spectrum light sources by virtue of their deviation from white toward either a blue or red cast. That is

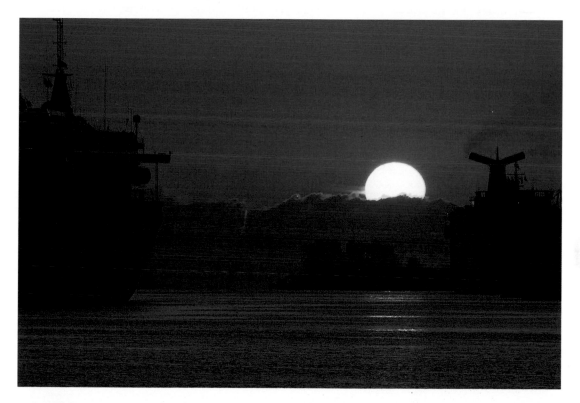

You can almost feel the heat of the low sun's orange-red light as it radiates close to the horizon (left). The effect of this illumination is opposite that of the cold blue light around these ice floes (below).

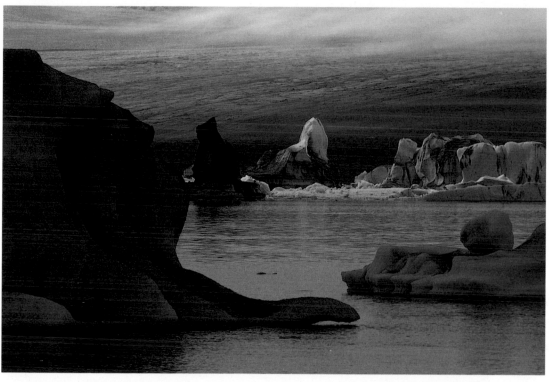

precisely what photographers do when they use the Kelvin scale of measurement (see Figure 1-4). The higher the Kelvin rating or temperature, the cooler the light. It is very important for you to know the Kelvin temperature of the light you're working in because photographic film is balanced for a particular temperature (see page 21).

Three artificial light sources are manufactured according to standardized Kelvin temperatures. These are electronic flash units, which are usually rated between 5400K and 5600K depending on the brand, and tungsten and quartz lighting, both of which are rated either 3200K or 3400K. Sunlight isn't a standardized source because its rating varies during the course of the day. It can, however, be used throughout most of its range and still deliver a satisfactory color palette. Daylight is usually thought of as between 5000K and 5600K. Clearly, then, tungsten and quartz lighting

FIGURE 1-4. KELVIN TEMPERATURES FOR COMMON LIGHT SOURCES

Source	Degrees (in °K)	Approximate Percentage (Selected)		
		Blue	Green	Red
Clear blue sky	10,000–15,000			
Overcast sky	6000–8000	39	34	27
Sunlight, noon, high altitude	6500			
Sunlight average (4 hours after sunrise and before sunset)	5400–6000	33	33	33
Electronic flash (studio)	5400–5600			
On-camera flash	5400–6000			
Daylight blue flood lamps	4800			
Studio photo floods	3400			
Studio tungsten bulbs	3200 or 3400	20	30	50
Studio quartz bulbs	3200 or 3400			
Household lighting	2500–3000	7	32	61
200–watt bulb	2980			
100–watt bulb	2900			
75–watt bulb	2820			
60–watt bulb	2800			
40–watt bulb	2650			
Single candle	1200–1500			

Neutral areas, such as white walls in shade, are very susceptible to color casts caused by reflections. Here, the marble floor produces a green cast in the shade. A CC10 magenta filter would probably have "cleaned" the shadows without producing a shift in the white. I did, however, use a polarizer to deepen the blue sky.

favor the warmer end of the color spectrum, while daylight is skewed toward the cooler portion. Indoor household lighting, firelight, and candlelight are even warmer, and midday sunlight in snow is much cooler.

PHOTOGRAPHIC FILM

One of the main reasons for standardizing lighting sources is so that it can be matched to the film whose colors are proportionally balanced to the light source. This produces a correct rendering of the colors in the scene. There are three classes of color film: *daylight,*

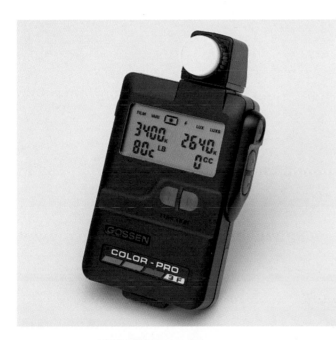

usually balanced for 5500K; *tungsten Type A,* balanced for either tungsten or quartz 3400K bulbs; and *tungsten Type B,* balanced for these tungsten or quartz 3200K bulbs. All color-transparency or color-slide film is rated in this manner, so you must pay careful attention to the matchup between film and light because there is very little opportunity to correct for any mistakes during processing. Tungsten film has significantly more blue to help balance the high levels of red in tungsten light, while daylight film carries a larger proportion of red-yellow to offset the high amount of blue in sunlight.

Color-negative film is intended to record the scene and then used to print enlarged photographs. Because it is possible to control the color of the enlarger's light, you can make significant changes in the chromatic rendering in the final print. Therefore, the matchup of film to light source isn't as critical here. You can shoot daylight-balanced color-negative film under a variety of light sources and color correct during the printing process.

Taking into account the differences between the various color-film emulsions, you can generalize that transparency films show the effects of filters more completely and are capable of recording more subtle effects than color-negative films. There are many reasons for this, but the most significant is the difference between the two types of emulsions. Negative films don't equal transparency films' ability to show the finest detail and color rendering because their final result is a print produced through a lens and

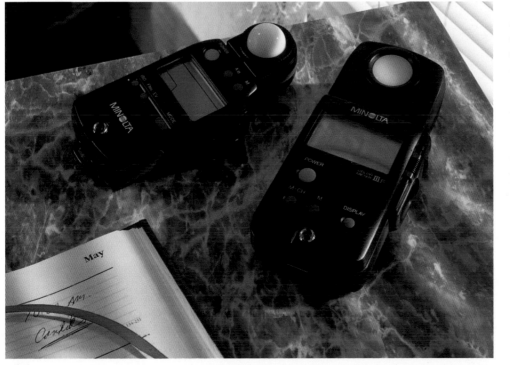

Color meters provide essential information about the color quality of a light source. Although they are very expensive, they are extremely useful to photographers who must control chromatic qualities. Two models are the Gossen Color Meter 3F (above left) and Minolta's Color Meter IIIF (left) on the right, next to a standard white-light meter.

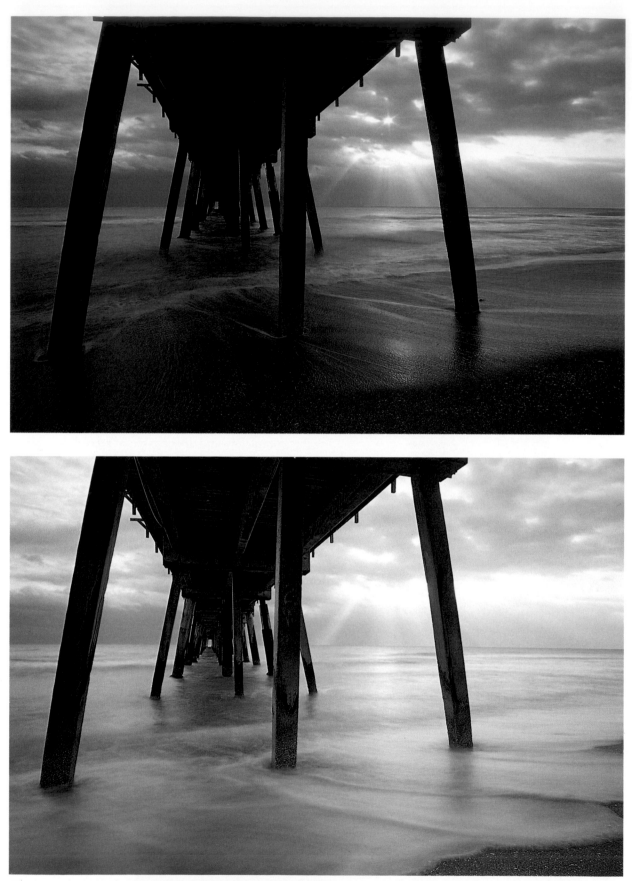

Some scenes exceed a film's ability to record a particular brightness range. In these two pictures of a sunrise framed by a pier, I had to choose between detail in the highlight areas of the sky (top) and detail in the shadows of the pier (bottom).

viewed by reflected light. Consider the potential influences on this second-generation image: the quality of the light from the enlarger, the effect of the enlarging lens on sharpness and light quality, the influence of printing chemicals, the surface of the paper used as well as its own photo chemistry, and, finally, the effective loss of quality produced by reflected-light viewing. With transparency films, the variables are reduced to the quality of the illumination of the viewing table and the loupe used to view the light coming through the first-generation image. So if you want to see the most complete, purest effect of a filter, use transparency film.

Black-and-white film isn't rated as "tungsten" or "daylight" simply because there isn't enough of a difference in the light sources to change the response of the film, except under very critical conditions. The *ISO,* or *film-speed, rating* of most monochrome film is based on daylight, so at worst you may need to add slightly more exposure when shooting a black-and-white film under tungsten lighting. This happens frequently when you use a copystand. Here, the usual

adjustment is one half to one stop more exposure. Manufacturers describe this in the film's instructions and explain that you should lower the ISO rating accordingly, from ISO 125 to ISO 80 for example.

LIGHT MODIFIERS

One of the often overlooked influences on light is the effect of light modifiers, some of which occur naturally and others that are manufactured. Standard studio modifiers, such as umbrellas, soft boxes, and diffusion screens are designed to change small, powerful light sources into medium or medium-large ones. If you point a flash into an umbrella, the light will bounce off the sides and spread out when leaving the umbrella, thereby greatly increasing the size of the light source. This is what happens when sunlight bounces off a white wall near a window and reflects into a room to produce a medium to soft light. A diffusing panel set in front of a flash head or a light bulb acts like clouds on a bright, overcast day, also enlarging the size of the source. Soft boxes combine the reflection of an

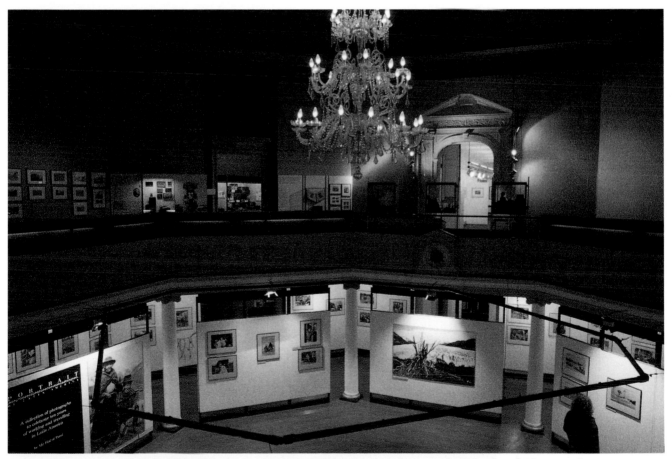

I chose the warming effect daylight film gives in tungsten lighting for this photograph of the Royal Photographic Society's Octagon Gallery in Bath, England, in order to represent the historic atmosphere of this building.

umbrella with the diffusion of a front panel for a slightly different, medium-light source.

Generally, all artificial devices, along with large reflecting panels, are made of bright white or silvery material that doesn't significantly alter the Kelvin temperature of the light as it bounces off or goes through the material. You can, however, affect the color temperature by using, for example, a gold reflector to significantly lower the Kelvin rating of the light for a noticeably warm look, or, less commonly, a bluish liner for a cool effect. So as a group, the effect

on color of these light modifiers is controlled because they're manufactured to certain standards.

The physical environment, on the other hand, may contain its own modifiers that are out of your control and sometimes overlooked. A classic example involves the colored walls of a living room. Here the light from a camera-mounted flash bounces off the walls and absorbs some of the color as it reflects off the wall back into the scene. This is also a danger when using umbrellas: some of the light goes through the fabric, hits the wall, and may cause a color cast. This is why

It is very important to recognize and distinguish between the various types of environmental light modifiers and to keep an eye out for manmade versions because each requires different filtration. One of the most troublesome light modifiers is pollution. I used a graduated magenta filter and a CC20 red filter to compensate for it in this shot of waves crashing against a rock formation.

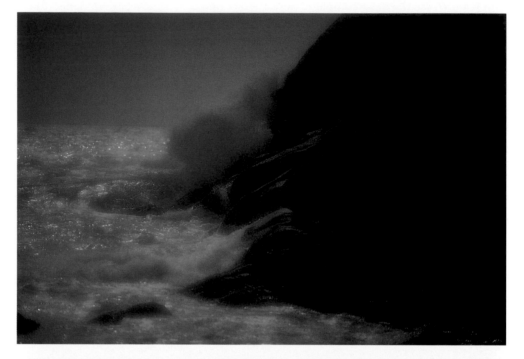

Without the aid of proper filtration, evening shots of illuminated skylines show variations in color; the green of fluorescent lighting often dominates these images.

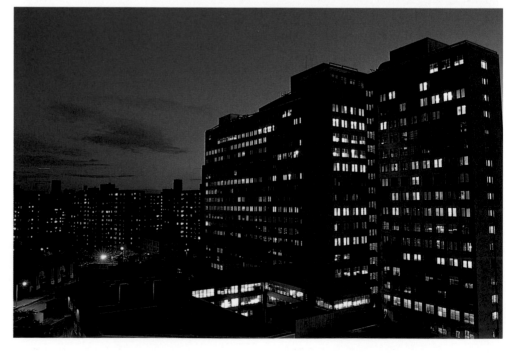

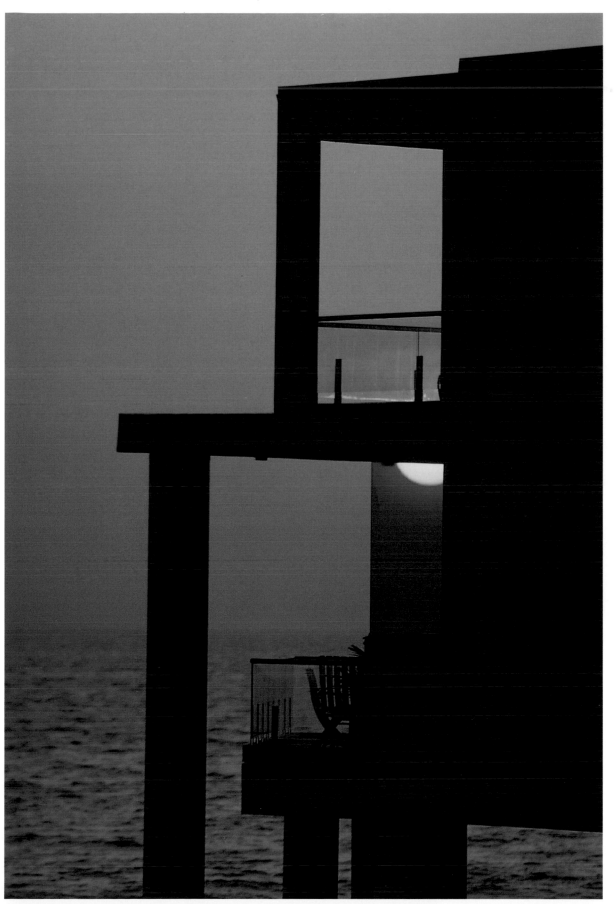

The presence of manmade light modifiers, such as the brown tint of this window glass, calls for careful filtration. To preserve the orange-red sunset look here, I chose a CC20 magenta filter to compensate for the effect of the window.

Single, strong filters and combinations of filters can be used many ways to create very different and dramatic effects. Clouds are among the favorite subjects for such applications. For this sunset sky, I used several strong Cokin graduated filters: a red FLO filter (top), a mauve filter (center), and an orange filter (bottom).

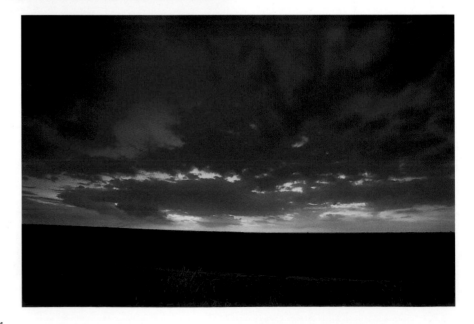

many photographers prefer to use soft boxes or black-backed umbrellas: with these light modifiers the light can come out through the front only. Black-backed umbrellas, incidentally, don't increase light output over silver ones because the black fabric itself acts like a filter to absorb the light. So with the exception of such materials as gold or blue liners, studio light modifiers are intended to control contrast and its effect on highlights, middle tones, and shadows by altering the size of the light without altering the color of the light source.

Environmental light modifiers, which include pollution, dust, clouds, mist, rain, and haze, constantly vary. It is very difficult to quantify these conditions exactly when shooting. So when you decide to use filters to enhance their appearance, you'll find the process far less precise than controlling studio light. You can, however, use filters to deal with these conditions. Filters, then, are light modifiers whose main purpose is to enable you to control or correct the effect of other modifiers or the light source itself.

Shooting tungsten film in daylight produces a distinctive blue cast that creates the look of a night shot when slightly underexposed. To increase the appeal of a landscape that was adversely affected by haze and humidity, I decided to combine a graduated tobacco filter and a CC10 magenta filter (left). For the photograph of the canyon, shot with daylight film, I used an 80A conversion filter and a CC40 magenta filter together (below).

HOW FILTERS WORK

If you know the color and contrast qualities of light, differences in films, and types of light modifiers, then the options for filtration will be evident to you. To complete this strategy, you have to understand how filters actually produce their effects on each attribute of light before you can utilize them. A convenient way to do this is to look at filters in terms of the function they perform in the final image.

Any review of filters must also address the questions of filter quality, proper use, and the various "systems" available. It seems that manufacturers have spared no effort in coming up with different designs and materials to meet every possible need. To experienced photographers, much less neophytes, these many choices can be confusing if not overwhelming. Consequently, you need to be aware of the advantages and disadvantages of the many options available.

In this product shot, the color temperature of the studio strobe caused an abundance of cool blue reflections. To correct for this I relied on a CC10 yellow filter to warm up the subject.

Photographers can use filters in the field or in the studio to make very slight changes. Here I chose a strong color-compensating filter to enhance the red effect.

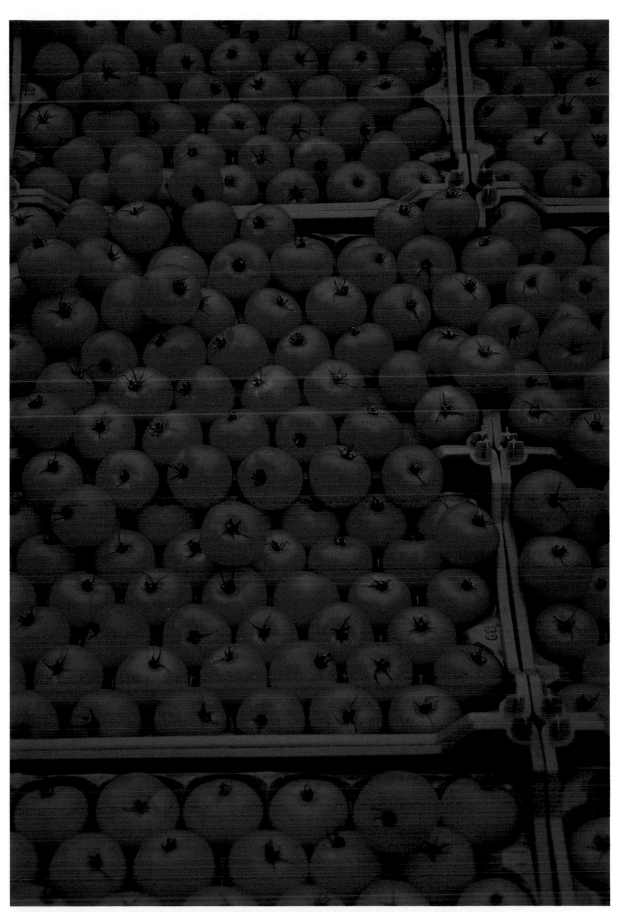

For this photograph of tomatoes, I selected an 81A filter to correct for the excess blue produced by their shady location.

CLASSIFYING FILTERS BY FUNCTION

A filter can affect a light source and thereby alter the appearance of the final image two ways: by changing the proportions of colors in the light hitting the film, and by changing the behavior of the light waves themselves. Most filters fall into one of these two groups. Filters that change the color content of light are colored and are referred to as *chromatic*. Filters that physically change light waves and have no color are classified as *nonchromatic*. In general, the main functions of chromatic filters are to correct for color imbalance, or *color correction,* or to control color contrast. Nonchromatic designs, on the other hand, can be used to modify the light by reducing its intensity, cut down on glare and reflections, change the sharpness or focus range, or remove part of the non-color spectrum that film is sensitive to, especially the ultraviolet section. You'll find that some of these changes may be accompanied by an apparent change in the color of the final image, but this is usually a secondary effect.

A third category consists of a diverse group of special-effect filters. Their purpose isn't associated with the main functions of chromatic and nonchromatic filters. Instead, these filters are designed to produce a wide variety of effects that go beyond what you might think of as visual reality. Special-effect filters utilize both chromatic and nonchromatic mechanisms.

With the exception of being able to increase a light source's intensity, filters can affect all of its qualities in subtle or more obvious ways. Likewise, their results

can be altered by changes in the light itself. For example, the effect of a diffusion filter on a highlight area is much greater with a small light source, such as the afternoon sun, at a sharp angle to the subject, than with a large light source illuminating the overall scene, such as an overcast sky. You might find it helpful to think of filters along the lines of the musical concept of "variations on a theme." In essence, every prime effect can be modified, depending on the conditions under which you use the filter. Furthermore, filters can also have secondary uses, and they can be combined with other filters for still more variety.

Color-conversion and light-balancing filters change the Kelvin temperature of the light reaching the film. As shown on the far right, conversion filters are very strong and come in two colors: the 85 amber-orange series (top) and the 80 blue series (bottom). Light-balancing filters are available in two forms, the 81 amber series and the 82 blue series, and are much less dense in coloration. Here you see the 81C, 81B, 81A, and 85A amber filters (top row, left to right) as well as the 82C, 82B, 82A, and 80A blue filters (bottom row, left to right).

All I needed to give this shot extra warmth was an 81A warming filter.

Chromatic filters offer very strong colors, as you can see in these shots made with a 21A light-red filter (left) and a 25A red filter (right).

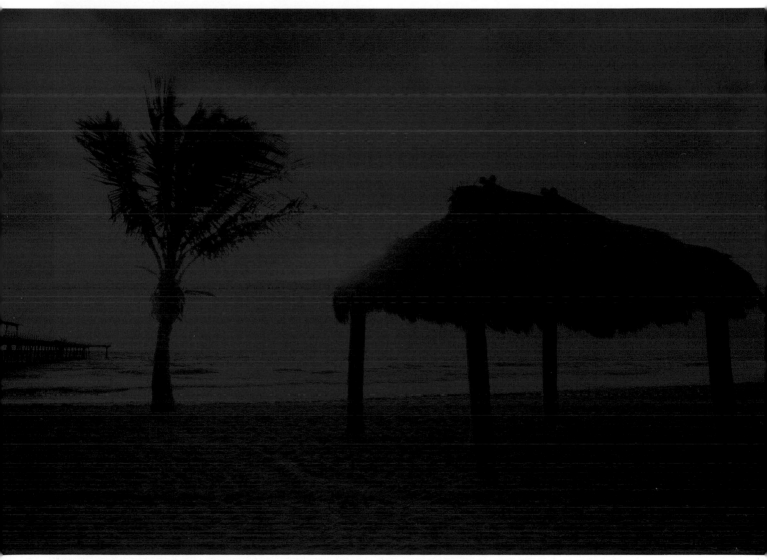

Here I used a chromatic filter to produce a very warm "sunset." I actually made this shot during the late afternoon, capitalizing on a bright spot in the sky.

CHROMATIC FILTERS AND COLOR CORRECTION

Correct rendering of colors in an image depends on synchronizing three factors; you have to match the color content of the light with the color response of the film in order to produce an image the viewer interprets as "correct." Aside from certain forms of scientific photography in which absolute standards for color are established, this combination of light, film, and perception isn't determined by a set of absolute, inviolable standards. More often, a range of "acceptable correctness" can be altered by such intangibles as the mood of the scene and the role color plays as part of the subject. Taken as a whole, then, you should look upon color correctness as a relative concept resting on some firm principles of color theory.

There are only three situations when film and light are theoretically color-balanced: when daylight film balanced for 5500K is used for shooting in sunlight with that same Kelvin rating, and when tungsten Type A and tungsten Type B films are used under standardized light sources of 3400K and 3200K, respectively. This balance is as near to perfect as the physical components of the process allow. Unfortunately, it is very common to have variations in daylight because its Kelvin temperature changes throughout the day, as well as in tungsten sources because of the aging process of the lighting filaments. Even studio flash units can show some variation, but this is consistent for each model. For example, one manufacturer may build 5500K flash tubes, while another issues 5600K units. This is one of the

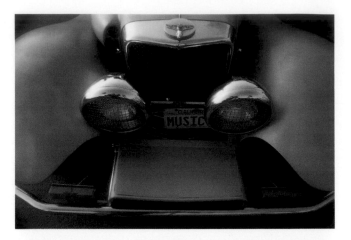

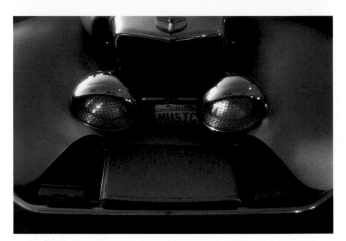

The comparative effects of the 81-series warming filters (top) and 82-series cooling filters (bottom) are shown in these two car shots made on daylight film. I also used a soft-focus filter for both photographs. And when I worked with the cooling filter, headlights from a second car were directed at the subject's headlights, which made it appear as if the car's lights were on.

FIGURE 2-1. MATCHING COLOR FILMS TO LIGHT SOURCES

Color Film Type	Balanced For*	Filter Required			
		Daylight	Photo Lamp (3400K)	Tungsten (3200K)	Clear Flashbulb (3800K)
Daylight	Daylight, blue flash, or electronic flash	No filter	80B	80A	80C
Type A (3400K)	Photo lamps (3400K)	85	No filter	82A	81C
Type B (3200K)	Tungsten (3200K)	85B	81A	No filter	81C

* The correct color balance between film and light source occurs only when the Kelvin temperatures equal each other.

Very warm filters that provide a sepia-tone effect are considered to be special-effect filters because they do so much more than what the 81- and 85-chromatic-series filters do. Here I combined a Cokin version and a Harrison and Harrison #5 diffusion filter for a nostalgic rendering.

reasons why you shouldn't mix different brands of flash in critical color work. Incidentally, smaller, on-camera flash units are notorious for their cooler color temperatures.

LIGHT-BALANCING FILTERS

When a light source and the film you're using have slightly different Kelvin ratings, you can use *light-balancing filters* to re-establish the matchup. These filters come in two forms. The 81 series, colored yellowish-amber, lowers the Kelvin temperature in increments of several hundred degrees, and the 82 series, colored light blue, raises the temperature over a similar range. These filters ordinarily are used on the camera lens. Lighting gels of similar ratings, on the other hand, are put on the light source to change the spectrum. The primary function of these filters (and gels) is to reach as perfect a Kelvin balance between the light and the film as possible. (It isn't a good idea to use gels intended for light sources with a camera lens because they don't have the same optical quality as camera filters.)

A secondary, and very popular application, for the 81- and 82-series filters is to use them to add warmth or coolness to an already properly balanced scene. For example, lowering the Kelvin temperature of an outdoor, summertime portrait 200 degrees with an 81A filter or raising the Kelvin rating of a snow scene 300 degrees with an 82B filter accentuates the mood of each shot. When light-balancing filters are employed this way, they're frequently referred to as *warming filters* and *cooling filters*.

COLOR-CONVERSION FILTERS

What happens when you shoot tungsten film outdoors or daylight film indoors? As discussed earlier, there is a massive shift in the blue or red-yellow portion of the color spectrum. So tungsten film's heavy blue content imposes that color onto a daylight scene, and the excessive red-yellow content of daylight film adds that hue to a scene shot under typical indoor light. Light-balancing filters aren't enough to close the gap in temperature differences that now measures in the thousands of degrees Kelvin and not the hundreds. In

FIGURE 2-2. THE EFFECTS OF COLOR-CONVERSION FILTERS ON WAVELENGTH TRANSMISSION OF LIGHT

85 Series Orange Conversion Filter

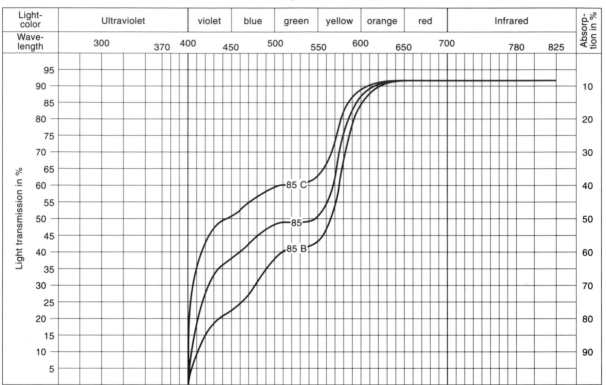

80 Series Blue Conversion Filter

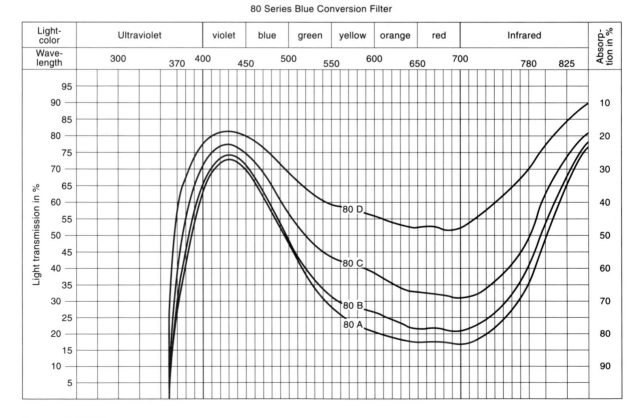

Courtesy of B&W Filters.

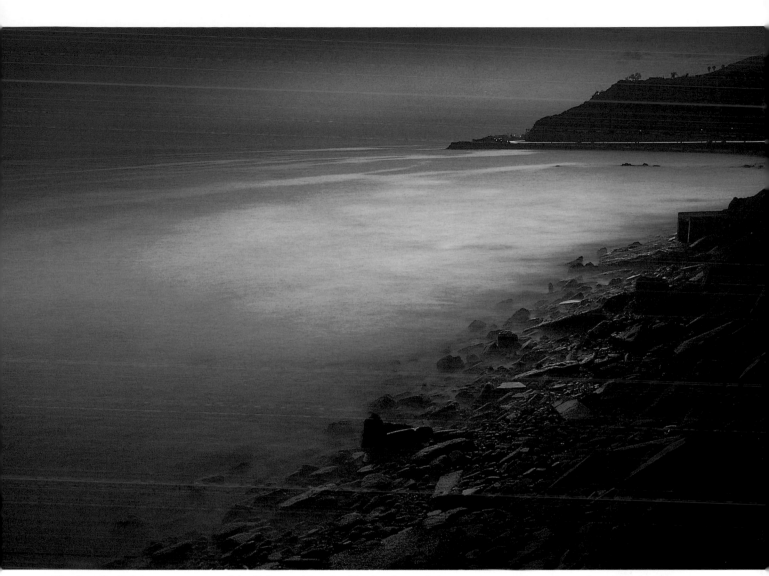

To alter the Kelvin temperature of the light reaching the film for dramatic impact, you need to mismatch conversion filters with film and light sources. For this shoreline scene I shot daylight film with a conversion filter intended to convert tungsten film for use in daylight.

such shooting situations, you need a major shift. This calls for *color-conversion filters;* these also come in two forms. The deep blue 80 series and the deep orange 85 series work on the same principle as the light-balancing filters, but they make the much larger shifts required for converting tungsten film outside and daylight film inside (see Figure 2-2).

As with light-balancing filters, many photographers produce an interesting secondary effect with conversion filters: really shifting the mood of a scene. For example, you can change the drab gray of an overcast day to a cool, mysterious, deep blue by using an 80-series filter with daylight film. Alternatively, shooting a fireplace scene indoors under typical household lighting with tungsten film and an 85-series filter results in an extremely warm image.

HOW LIGHT-BALANCING AND CONVERSION FILTERS WORK

Shifting the Kelvin temperature of a light source to refine its color balance or to convert it for a particular film, whether the change is slight or major, is a straightforward process of matching Kelvin temperatures. Just exactly how is this accomplished? That is, what happens to the spectrum to change it to match the film when you use these colored filters? Once again the subtractive process comes into play. All chromatic filters remove part or all of certain wavelengths, thereby changing the proportions of color in the light reaching the film. Because tungsten light sources have low levels of blue, tungsten-balanced films have large amounts of blue in their emulsions. When combined, then, the light sources produce the correct proportions of blue. Here, the designation of

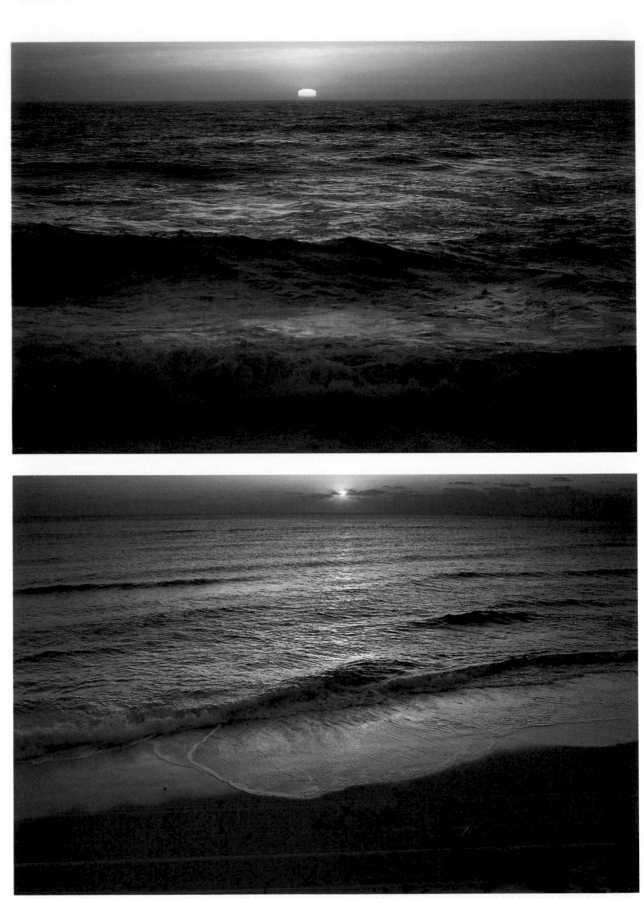

Filters can render the same scene in very different ways. For one seascape, I chose a CC30 magenta filter to enhance the color of the water and give the sky a deep orange color (top). Notice the flare reflection of the sun under the wave. In another seascape, I used an 80A conversion filter to give the water a definite blue color (bottom).

a low rating of 3200K represents two different things. In terms of a light source, it means reduced blues and a preponderance of red-yellow. The same rating on a film box actually means the emulsion is biased to the blue end of the spectrum. This is why when you use tungsten film in daylight, which already has a significant amount of blue, you get a strong blue cast.

If you add a conversion filter, it will block, to some degree, all colors except its own; it allows this color to pass. This subtractive process can be plotted for each wavelength (see Figure 2-2). So a deep blue conversion filter, such as the 80A, enables you to use daylight-balanced film, which has proportionally more of its emulsion sensitized to the red-yellow end of the spectrum, under tungsten light with its high red-yellow content. The blue of the filter holds back much of the red-yellow, but allows virtually all the blue through. The result is a color-balanced picture. By putting a blue filter on your lens, you aren't adding more blue than is already in the light. You're actually changing its proportion in relation to the other colors, particularly the red-yellows, by blocking those wavelengths. The extent of the blue or red-yellow shift depends on how much you're affecting the proportions. This is controlled by the *density*, or deepness, of color in the filter. A light amber-yellow 81A filter, then, causes only a slight warming while an 85A filter with its much denser amber-yellow appearance produces extreme warming, to the point of conversion.

COLOR-COMPENSATING FILTERS

Color-conversion and light-balancing filters are basically concerned with shifting the color temperature of a light source, which affects primarily the cool and warm ends of the spectrum. What happens, however, if your film has too much green, yellow, or magenta? Perhaps you want to show a pinkish overall cast. None of the color-correction filters discussed earlier can help. You now need to filter for individual colors. This requires using the most specific type of filtration available, *color-compensating (CC) filters.*

These filters offer ultimate color control, and come in six colors—red, green, blue, yellow, magenta, and cyan—and in different density (strength) increments of 0.10 on a scale ranging from 0.10 to 1.00. Filters with ratings of 0.025 and 0.05 are also available, so any one of the 0.10 densities can be made into half and quarter steps by combining filters. For example, an 0.05 filter plus a 0.30 filter equals a 0.35 filter. The full designation indicates the filter color and density,

so a CC35M filter is a magenta color-compensating filter with a density of 0.35.

Obviously with this kind of selectivity and specificity, your ability to control color balance is quite expanded. You are able not only to block out colors other than red and blue, but also to make extremely fine adjustments in color temperature in the same way, by using CC equivalents of the 81 and 82 series. CC filters are especially useful under the following conditions:

1. Although manufacturers try to control the color content of their films, there are variations from batch to batch. The only way to make very critical corrections, so that you can rely on the whole batch delivering exactly the same rendering, is to use CC filters. This applies to the most critical of color control.

2. Most photographers meet their first need for CC filters when they start duplicating slides or printing color negatives. When used for printing, CC filters are referred to as *color-print (CP)* filters. In both slide duplication and printing, a filter pack is calculated

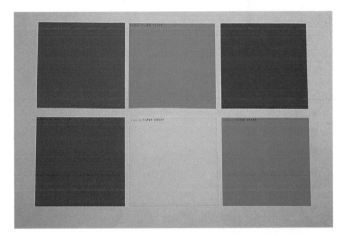

Color-compensating filters come in the primary colors, usually in square-gelatin form with a .50 density (top). The entire range of yellow filters from .25 to .50 density indicates how exact your control of color can be (bottom).

through testing and is used on all duplicating film of the same batch number for slides or for the same negative when printing.

3. Photographers also benefit from using CC filters to compensate for the color shifts that occur during long exposures. Here, film can't record colors as it does when more common, faster speeds are used. The resulting problem can be a chromatic shift requiring correction. For example, Kodachrome 64 Professional film requires a CC10 red filter with a 1 sec. exposure. The solution is to use CC filters to re-establish the correct color rendition.

4. Finally, CC filters can be used for a number of different applications. These encompass virtually any situation where the environment conspires to make it difficult to obtain correct color balance. For example, for shooting through tinted glass you want to use a CC filter that is complementary to the color of the glass.

Photographers, who duplicate their transparencies, work with color-correction filters all the time to offset variations in the film emulsion being used and, in some cases, in the light source.

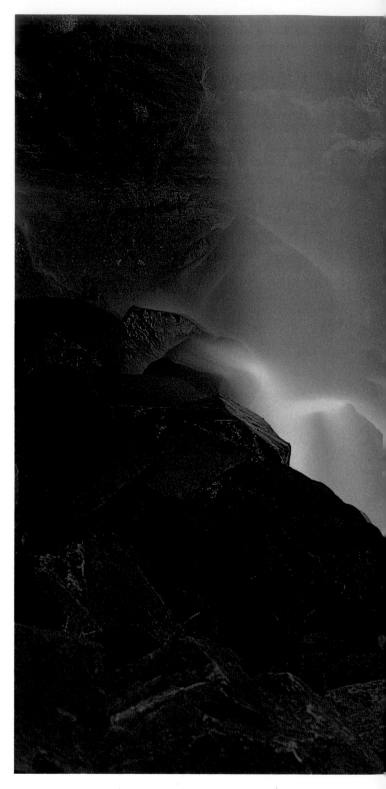

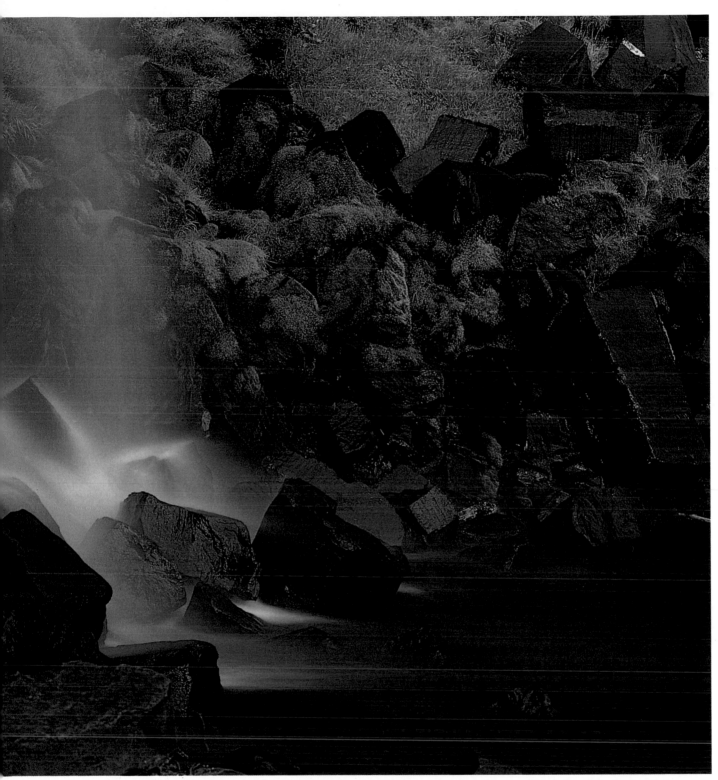

Extremely long exposures often result in color shifts in the film's emulsion, as seen in the color of the water in this 6-minute exposure.

Introducing extreme chromatic contrast invariably creates dramatic effects as seen here in this shot of the Golden Gate Bridge (above), which combines a CC40 magenta filter with a polarizing filter. In the slot canyon shot, a combination of a CC30 red filter and a CC10 magenta filter converted the subdued colors of the sandstone into a much bolder rendering (opposite page).

Under fluorescent light, you choose a CC filter that will offset the excess green that this light source characteristically produces. Whatever the shooting situation, you have to subtract one or more of the colors in varying degrees from the light hitting the film.

HOW DO CC FILTERS WORK?

For all their usefulness and potential for creativity as well as corrective applications, CC filters are least understood and used of all the chromatic filters. In order to learn how to use them effectively, photographers must understand how CC filters change color proportions. And to attain a masterful level of understanding and utilizing CC filtration, which will be a real door-opener if you love to experiment, you should memorize the principles of applied CC filtration and think about them in terms of every picture-taking situation until they become part of the way you evaluate each scene (see Figure 1-3).

The relationship between the additive primaries (red, green, blue) and the subtractive primaries (cyan, magenta, yellow) forms the basis of all CC filters. You can purchase and combine these six colors in a number of strengths to affect the color in a photograph across an almost infinite scale of changes. But how do you decide which filter to use? By the simple rule of thumb

stated earlier: A filter allows its own color to pass and blocks (to one degree or another) all other colors via the subtractive process. This is very easy to understand for the additive primaries: a blue filter transmits blue and blocks red and green, a red filter transmits red and blocks green and blue, and a green filter transmits green and blocks red and blue.

The situation becomes a little more complicated with the subtractive primaries because each is made up of two colors. Magenta, which is composed of red

Darkroom workers use color-print filters to view prints, evaluate color balance, and make adjustments when printing.

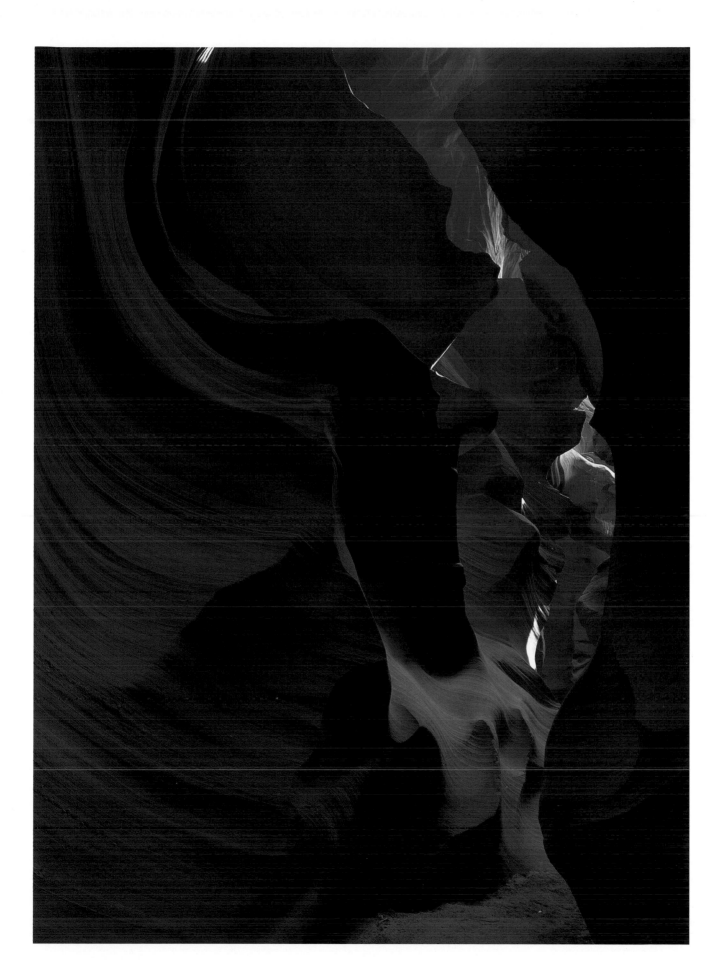

FIGURE 2-3. THE EFFECTS OF COLOR-COMPENSATING FILTERS ON WAVELENGTH TRANSMISSION OF LIGHT

Green Filter

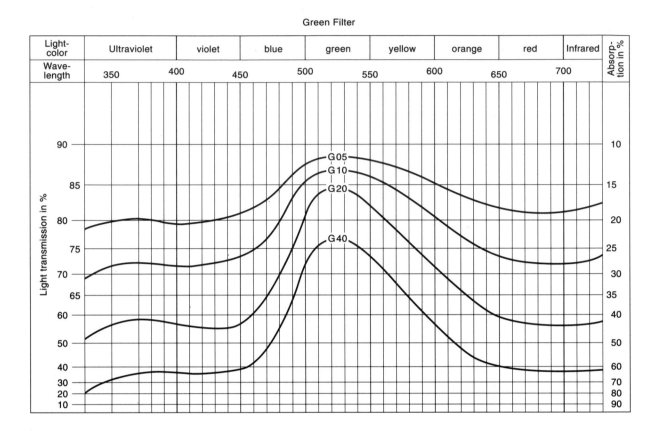

Magenta Filter

Courtesy of B&W Filters.

and blue, transmits red, blue, and magenta and blocks green. Cyan, which is composed of blue and green, transmits blue, green, and cyan and blocks red. And yellow, which is composed of red and green, transmits red, green, and yellow and blocks blue.

The concepts of additive primaries, subtractive primaries, and complementary colors, along with the principles of subtraction through filtration, are the major tenets color photography is based on. For example, when darkroom workers want to color-correct a negative for too much green, they might choose a magenta filter of sufficient strength to override (absorb) the green effect. The same principle applies when you shoot under fluorescent lighting, which characteristically has an abundance of green. Here, you place a CCM (magenta) filter over the lens. Even the layers of transparency film are divided into magenta, yellow, and cyan; you can readily see them by tearing a piece of film and looking at the layers within the torn edges. These color-sensitive layers react to the colors in the light reaching the film to produce the final image.

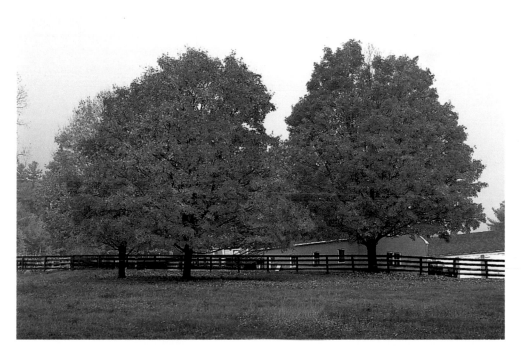

Didymium filters, better known as enhancing filters, have become popular among photographers, and several types are now available. They have the unique ability to enhance the warm colors in a scene without significantly affecting greens and cool colors. So didymium filters are particularly effective with fall foliage, as shown in these before (top) and after (bottom) pictures shot with an enhancing filter made by Tiffen. You must be careful with these filters because they can also cause a noticeable color shift in white areas.

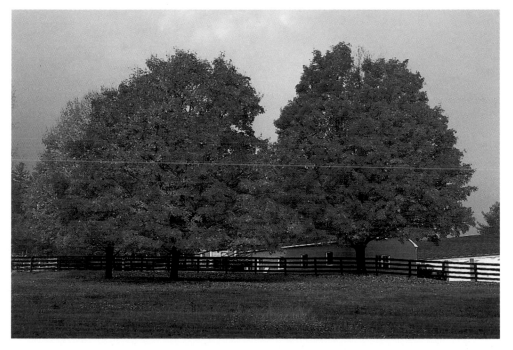

CHROMATIC CONTROL
OF CONTRAST

Unfortunately color contrast can't be quantified in terms of brightness the way a gray scale shows differences between black-and-white tones. The fact is, color carries much more "emotional baggage" than black and white. Think of the clash between complementary colors. So you have to consider many more influences than just brightness, such as: the mood of a scene, particularly as influenced by warm or cool colors; the impact of a number of deep, rich colors in a scene versus only one; and a light or pastel color within an otherwise colorless background. Quite obviously, contrast is a complex subject.

Perhaps the easiest way to affect contrast in color films is through the purity of the colors themselves. Take, for example, a saturated, deep blue sky against an equally saturated red building with green doors on a sunny day. Each element stands on its own and demands the viewer's attention. If, however, the sky is light blue and the building a weak red with just slightly darker green shutters, there would be less contrast because of the muted hues.

Color saturation is a consequence of color purity that can be enhanced two ways: either by directly affecting the color itself or "desaturating" other colors in the scene. You can do this to some degree via subtractive filtration by using chromatic filters, especially ones with color-compensating designs. The risk, of course, is that by changing the proportions of color reaching the film, you might tip the color balance too far in favor of one color and cause an imbalance, such as a color cast.

In practice, using CC filters to selectively increase color saturation while muting others is a limited process. What works more effectively is the use of *graduated filters,* or *grads.* These filters have color on only half of their area, which enables you to introduce color where none is present or boost a weak hue. I run across this treatment most frequently with sky shots. Choices in graduated filters are extensive today, particularly when two are stacked to expand the effect. For example, using a blue grad across the sky and a light tobacco grad on just the upper portion produces a scale of chromatic contrasts that rely on differences in hues rather than brightness. In the studio, you can

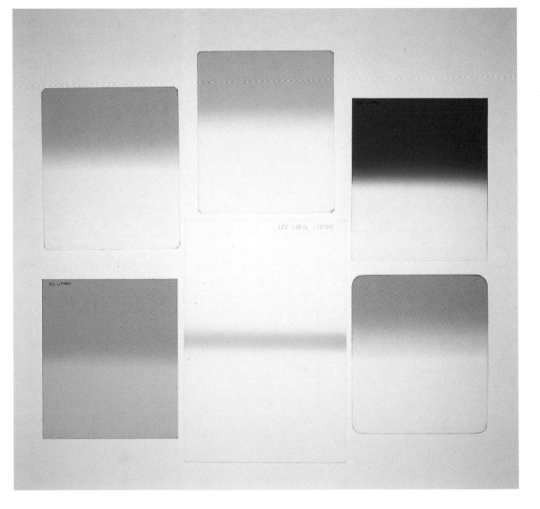

Graduated color filters first appeared in a limited number of single-color resin forms popularized by Cokin. In recent years, the selection has expanded to include a wide range of colors from several manufacturers, as well as a full line of glass filters by Tiffen. In addition, various kinds of duotone forms have become available (bottom left and right). Lee Filters also now offers a number of stripe filters in which the color occurs in a stripe across the center of the filter (bottom center).

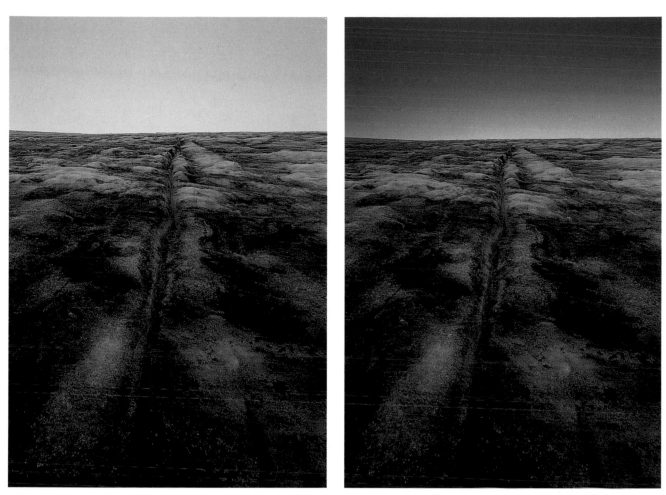

Graduated color filters are ordinarily used either to add more color to a portion of a scene to increase chromatic contrast or to introduce color, as shown here. Shooting a monochromatic scene on an overcast day (left), I added a Cokin graduated blue filter to improve the color of the sky (right).

press grads into service to add color to plain backgrounds when lighting isn't available. This applies to portraits as well as product shots. In fact product shots present more of an opportunity when done on a light table; here, you can mount the filters upside down to add color to foregrounds.

Finally, keep in mind that color correction often gives the secondary impression of increased contrast because the colors are more realistically presented and are therefore separated.

MONOCHROME CONTRAST

An earlier section on using colored filters with black-and-white emulsions discussed how all the principles of color filtration apply to the way colors are translated to monochrome. As such a red filter lightens red in a black-and-white print because more of this color reaches the negative for greater exposure. Contrast control then, as it relates to tones, is merely an extension of color theory. Consider, for example, the conversion of a standard color test card into black

and white (see Figure 2-1). At the very least, you should know how colors translate visually so that you can avoid dissimilar colors merging into very similar shades of gray. This is critical when such colors are a major part of the center of interest. For example, white clouds against a blue sky often translate with very little tonal difference between them. This renders the clouds and the sky virtually indistinct. To produce contrast between these two subjects, you can either darken the sky with a medium-yellow filter or cause the blue sky to go almost black with a red filter. If you don't know how a color translates, you risk not only a low-contrast rendering, but also a lack of separation between parts of the subject.

Consider a shot of a dark red brick building surrounded by trees and other green foliage. Red and green form very similar shades of gray, causing a merger of two important elements that should be portrayed as separate (see Figure 2-1). The solution is to increase the contrast between them by using a green filter. This will lighten the foliage and darken the brick

since, in black-and-white as well as color photography, a filter lightens its own color and darkens its complementary color. A red filter reverses the effect, producing an even greater contrast. You can use chromatic filters many other ways to increase contrast by separating tones or decrease contrast by merging similar tones. All of these applications depend on the principles of controlling shades of gray with color-contrast filters by using the principles of subtraction filtration (see Chapter 3 for more information).

CONTRAST AND NONCHROMATIC FILTERS

Other shooting situations that affect contrast in both black-and-white and color photography include when atmospheric conditions, such as fog and pollution, are increased or decreased; when reflections, glare, and/or flare is a problem; and when diffusion/soft-focus filters are employed (see Chapter 5). In all these cases the shift in contrast occurs not because of a change in the proportions of color in the light, but because something interferes with the light before it reaches the film. For example, fog and diffusion filters prevent light rays from properly focusing on the film, resulting in a photograph that has an "unsharp" or soft quality. And the end result in all these shooting situations, from fog to glare to flare to diffusion filters, is a lowering of contrast because of a decrease in saturation of the color or the gray tones. This is caused by a scattering of a portion of the light. So the purity of the color or tone is diluted by the stray light. It is important to remember that these broad ways of affecting contrast are far less selective than using a chromatic filter, and sharpness is always affected.

When you are up against such conditions as pollution or lens flare, which occurs when light strikes the lens and produces internal reflections of light, the outcome is generalized over the whole picture, and the result can more often be described with terms like "mood" or "atmosphere." This is also why these effects of a nonchromatic filter are considered secondary to such primary functions as soft focus or haze penetration.

FILTER CONSTRUCTION

Using filters also calls for an understanding of the construction material and how the filter is mounted to the lens. You have to weigh the many options available against your needs and resources. Filters are made from three types of material: optical-quality glass, gelatin film (gels), and rigid plastic resin. They attach to the camera lens via several systems. Most glass and some resin filters are permanently mounted in *circular rings,* designed to screw into the threaded front of a lens. Since gels are so thin they require a separate holder, which is also available in threaded fittings. The stiff plastic-resin designs have a bracket holder as well, but its slots hold two to four filters. There is even a system that stacks filters and lens hoods magnetically.

All of these mounting designs are available in the most common front-of-the-lens filter sizes of 49mm, 52mm, 55mm, 58mm, 62mm, 67mm, 72mm, and 77mm. There are smaller and larger sizes, as well a combination sizing called a *series*. For example, series VI filter has a nonthreaded filter about the size of a 49mm screw mount that's held in a circular bracket with a set ring. The whole assembly is then threaded into the lens front. To fit the filter on a smaller lens, you simply have to buy a bracket with that particular thread size. Other series filters are designated VII, VIII, and IX. These cover all filters that range in size from 52mm to about 86mm.

FIGURE 2-4. TRANSLATING COLOR INTO BLACK AND WHITE

Color in Scene	No Filter	Effect of Chromatic Filters*		
		Red 25 Filter	Green 58 Filter	Blue 47 Filter
Red	Gray	Light gray	Gray–black	Gray–black
Green	Medium gray	Gray–black	Light gray	Gray–black
Blue	Gray–black	Gray–black	Gray–black	Medium gray
Yellow	Light gray–white	Light gray–white	Light gray–white	Gray–black
Magenta	Medium gray	Light gray	Gray–black	Medium gray
Cyan	Gray–black	Gray–black	Medium gray	Medium gray

* These filters are intended for use with black-and-white films.

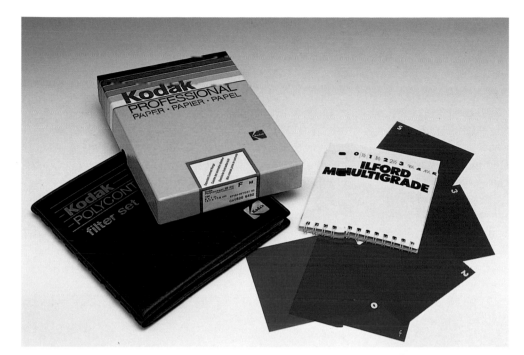

Certain variable-contrast black-and-white printing papers are designed to change contrast in response to special chromatic filters. These are very useful to darkroom workers who don't want to keep many different grades of paper on hand. Variable-contrast filtration requires an adjustment in exposure as the filter becomes more dense.

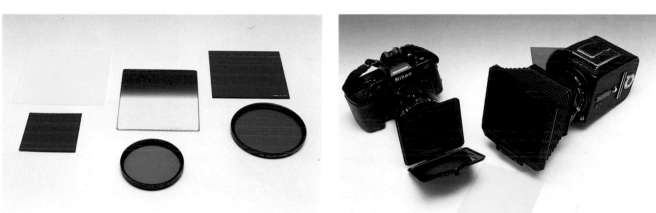

Camera filters are made out of optical glass, resin plastic, and gelatin. The most common sizes for thin, flexible gelatin discs are 3 x 3 inches and 4 x 4 inches. Most glass and resin plastic filters have circular thread mounts or square or rectangular mounts.

Filter designs are based on various mounting systems. Gel types are usually mounted in a clamshell arrangement (left) or a front bracket drop-in (right). Some lens hoods, such as this Hasselblad professional lens shade, provide a slot for a drop-in gel.

Most filters are mounted on the front of the lens. Sometimes, however, it is impractical to use a front mount, such as with ultrawide-angle lenses, fisheye lenses, and super-fast telephoto and mirror lenses. All of these have enormous entry elements. Rear filters are either screwed into the rear element, inserted from a side mount, or built-in and dialed into place. Although these designs prevent wear and tear of frontal mounts and don't disturb the lens' regular hood, rear screw mounts are inconvenient because you have to take the lens off. Built-in filters are the easiest to use but limit the selection to four or five types. Insert side-mounts are the most convenient to use, but they also limit your

choices. Another advantage that you shouldn't overlook when selecting filters is that in general the smaller the filter, the lower the cost. So rear-mounted filters are generally cheaper.

When deciding between glass, plastic, and gel filters, remember that glass is the most wear-resistant and easiest to clean, but requires a separate filter for each different lens thread size. You can partially solve this problem by using inexpensive step-up or step-down filter adapter rings that allow you to put, for example, a 67mm filter on a 58mm lens. Don't place a smaller filter on a larger lens because *vignetting*, or darkening, of the corners in the picture will occur.

Rectangular plastic, square gels, and series filters have the advantage of being mounted in their own bracket, each of which can be purchased for one lens size. Since the gels and plastic filters that fit these are all the same size, you don't have to buy separate filters for each lens. With circular series filters, you need several sizes to cover the whole range of lens filter sizes.

The disadvantage of using gels is that they are very thin and flimsy, scratch easily, and are very difficult to clean. They're also becoming more expensive. Plastics are better to deal with in this respect, but aren't as rugged as glass. Of course, they aren't likely to shatter if dropped. Finally, gels are available in far more categories than the others and, in fact, some chromatic configurations come only in gel form.

THE QUESTION OF QUALITY

While plastic resin filters have become much more popular, many photographers feel that they aren't up to the quality of the better glass filters and most gels. This is a very difficult question to address because there are few published tests to base comparisons on, and the technology that produced the original resin filters several years ago has improved. Based on the available data and my own extensive experiences with all types of filters, I find the following generalizations to be valid.

There are only certain conditions when the possible quality differences between the use of a single plastic, glass, and gel come into play. These are when critical color control is required, when strong light

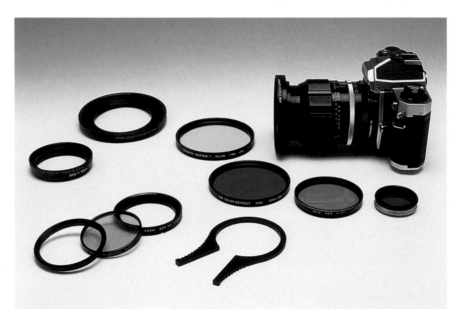

Some resin plastic and most glass circular filters are mounted in threaded rings that you screw onto the front of a lens. The most common sizes are 49mm, 52mm, 55mm, 58mm, 62mm, 67mm, 72mm, and 77mm. With the series sizes an unthreaded filter is put into a threaded holder, which has one of the common lens sizes, and is held in place by a retaining ring (lower left). To match a larger filter to a smaller lens, you need a step-down adapter. This camera usually takes a 62mm filter, but has been equipped with a 72mm adapter. Other step rings are also available (upper left). A filter wrench grips jammed filters when you apply even pressure (bottom center).

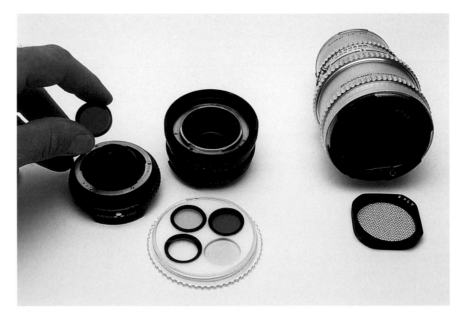

Some specialized optics, such as fisheye, ultrawide-angle, and long telephoto lenses, have rear-mounted filters that are dropped or screwed into place. Some lenses for large-format cameras also have rear-mounted gel holders. One of the few options for rear filters with medium-format cameras is made by the Yary Company; as you can see here, these black-net filters fit into the rear of Hasselblad lenses.

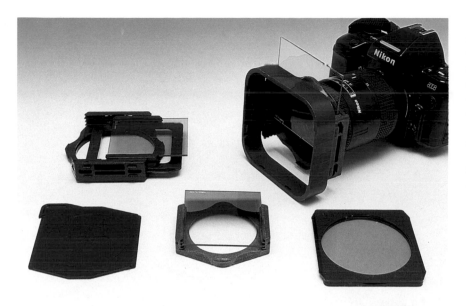

There are a number of bracket-mounting systems for square and rectangular filters. Cokin makes two different sizes, the "A" (lower center) and the larger "P" (mounted on camera), as well as several accessories, including a snap-on lens hood shown on the camera-mounted "P" filter, a holder for gels (lower right), a lens cap (lower left), and a special bracket that permits the use of "A" filters in a "P" bracket (upper left).

sources hit the filter, when the negative's going to be enlarged more than 10 times, and when more than one filter is used. Under these conditions you are likely to see differences when resin is used instead of glass or gel. The most common effect is a very slight loss in sharpness and/or, for want of a better term, may be referred to as a lack of color purity.

Under most general conditions, however, you won't see a major loss of quality with resin. I've used them for years, side by side with gel and glass, with only occasional noticeable effects in landscape work as well as typical studio setups in cameras taking 35mm, medium-format, and 4 x 5-inch film. The most common problem in all cases was a loss of sharpness in fine detail.

The single, most critical factor relating to ensuring image quality is cleanliness. You must keep the filter free of scratches as well as any buildup of dirt and smudges. This is as important and as essential as using a lens hood or some other device to prevent light from hitting the filter.

When you use more than one filter, image quality can also be affected by stacking too many in front of the lens. The usual accepted limit is two for plastic and glass and three for the thinner gels. Image sharpness can also be sacrificed when the filters aren't mounted parallel to each other and the lens, such as when a filter is simply taped to the lens rather than used with the proper holder.

Does the use of any filter degrade, or decrease the sharpness of, the image? The answer is yes, but the degree of interference is the really important question. The only way to get a definitive answer is for you to test them for your uses.

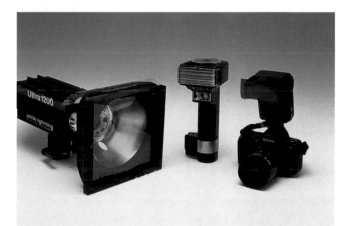

Another filtration option is to mount colored gels over the light source. For example, studio strobes usually have accessory filter holders (left), as do many on-camera flash units (center). You can also tape a small gel over the flash head (right).

One final point about filter quality relates to the filter's designation. The most commonly used system of filter names and numbers in the United States is the Kodak Wratten system (I use this nomenclature throughout the book). And while the same labels may be used, you'll find some differences in color and density from brand to brand.

THE NEED FOR LENS HOODS

These are a must with filters because of the increased chance of flare, which is caused by putting another surface in the light's path to the film. In the case of circular glass designs, you can screw your regular hood onto the filter. As for bracket-mount models, some have accessory hoods while others have to be used in conjunction with a *professional hood*. This is a

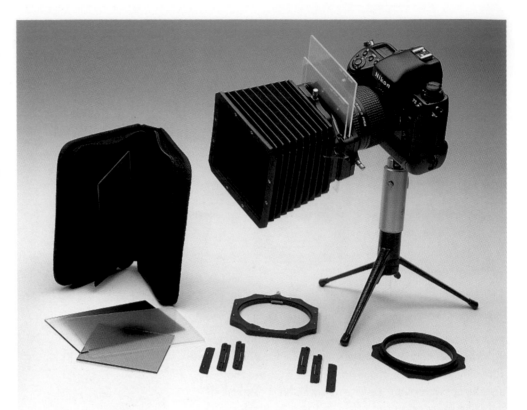

The Lee Filter System is an example of a versatile square/rectangular mounting system that provides for combining different filter thicknesses and sizes with standard and wide-angle adjustable hoods. You can put together different size filter slots (foreground) on the holder to hold Lee filters and thin polyester gel filters and other filters, such as Tiffen and Cokin P filters, when mounted in special Lee cardboard holders. A zippered filter wallet holds up to 10 filters.

bellows hood that expands or contracts depending on the lens' angle of view. This applies to both telephoto and standard lenses.

With the exception of moderate lenses, such as a 35mm lens in the 35mm format, vignetting is a real problem when filter stacking with wide-angle and especially ultrawide-angle optics. Even the use of one filter requires large, clumsy hoods in some cases. I've given up trying to find an easy-to-carry hood for my ultrawide-angle lenses, so in the field I rely on the very simple process of hand-shading the lens during exposure. You can often see vignetting caused by a lens hood or stacked filters in the viewfinder of a *single-lens-reflex (SLR)* camera or on the groundglass of a large-format camera. However, in low-light conditions this isn't always possible. Furthermore the viewfinders of many SLR cameras don't show 100 percent of what you're actually recording on film. Again, test your combination before trusting it.

CALCULATING EXPOSURE WITH FILTERS

The most important adjustment you need to make to your established camera techniques when using filters involves the calculation of correct exposure. Because color filters work on a subtractive principle, they hold back some light, necessitating an exposure adjustment. The exact amount of this change in exposure has been standardized on a "filter factor" scale (see Figure 2-2). Each doubling of the filter factor (2X to 4X, to 8X, etc.) results in the need to increase exposure by the equivalent of one stop. So, for example, if a red filter carries the designation 8X, you must open three stops (or decrease the shutter speed an equivalent amount) from what your camera meter tells you without the filter in place. In general, adjustments of less than one third stop less light aren't made.

When you combine filters, the total light loss in stops must be added up and subtracted from the exposure. Be careful not to add up the filter factors. If you use filter factors to calculate exposure changes, you must multiply them. For example, if you use filter A with a 4X factor, you'll have to increase the exposure by +2 stops. If you then add a second filter, filter B, with the same strength (4X), the total increase in exposure will be +4 stops. The total of the filter factors is 8X, which calls for only a +3-stop increase in exposure (see Figure 2-1). So when you add up the filter factors, the shot will be underexposed by one full stop. The correct exposure, +4 stops, represents a filter factor of 16X; this is the result of multiplying the 4X factors of filters A and B. An 8X factor calls for a only +3-stop increase. This is a full stop below 16X, which is what the actual increase in exposure of 4 stops translates into.

Do handheld or in-camera light meters pick up the changes in light transmission and enable you to automatically adjust for filter factors? The answer is a

qualified yes. In most cases I've obtained accurate exposures using both types of meters, but there are important exceptions. For example, different scenes may contain disproportional amounts of colors in relation to the color of your filter. The result is different "correct" exposures for that filter as it allows more or less light through the meter. Generally, I meter a scene without the filter, calculate the factor, and turn on the in-camera meter to check it. For fast shooting I depend completely on the meter. Certain situations are

Photographers who have to work with color-correction calculations might find this Focalware calculator handy. One of its many functions is to provide color-correction data based on the Minolta color meter.

There are many handy field guides for filter users. The most comprehensive is the Kodak Photo Guide, which has excellent filter dials for calculating proper filtration and exposure.

FIGURE 2-5. CONVERTING FILTER FACTORS TO *f*-STOPS

Filter Factor*	*f*-Stop
1X	—
1.2X	$^1/_4$
1.25X	$^1/_3$
1.4X	$^1/_2$
1.6X	$^2/_3$
1.7X	$^3/_4$
2X	1
2.4X	1 $^1/_4$
2.5X	1 $^1/_3$
2.8X	1 $^1/_2$
3.2X	1 $^2/_3$
3.4X	1 $^3/_4$
4X	2
4.8X	2 $^1/_4$
5X	2 $^1/_3$
5.7X	2 $^1/_2$
6.4X	2 $^2/_3$
6.8X	2 $^3/_4$
8X	3
9.5X	3 $^1/_4$
10X	3 $^1/_3$
11.4X	3 $^1/_2$
12.6X	3 $^2/_3$
13.5X	3 $^3/_4$
16X	4
32X	5

* Most chromatic and a few nonchromatic filters will block some light from reaching the film as a consequence of their effect on the wavelengths of light. This is indicated by a filter factor and the need to increase exposure as shown.

a real tipoff. For example, if you're using a green filter to subdue a red barn surrounded by heavy green foliage, the exposure reading you get through the camera will depend on how much green or red is in the picture. This is similar to metering off a white versus a black wall: you need to find gray. The best solutions are to take off the filter and calculate the factor into the meter reading, or to make your filter-on-camera reading off a gray card.

Since using filters means working with less light, you may find yourself using a tripod or moving up to a faster film. Be aware that both of these might affect your shooting style. Expect routinely to lose between one and three stops of light. This is a lot, but then again, think of what you're getting in return. The tradeoff is well worth it. My choice, incidentally, is to go with the slower film-tripod combination whenever the subject permits it.

USING CHROMATIC FILTERS WITH COLOR FILM

Now that you have a thorough understanding of the relationship between the colors of light, the color of a filter, and the reaction of film, you need to learn how chromatic filters affect color films to render distinctive changes. The guiding principle here is that these emulsions are made with specific amounts of colored materials that match certain light sources. Between them is the filter, which can alter the proportions of color wavelengths in the light to produce the specific effects on film that you want. You can then use filters not only in an orthodox fashion, but also as a basis for experimentation.

COLOR-CONVERSION FILTERS

These are the strongest filters available for changing the Kelvin temperature of a light source, enabling you to use daylight film under tungsten light or a tungsten

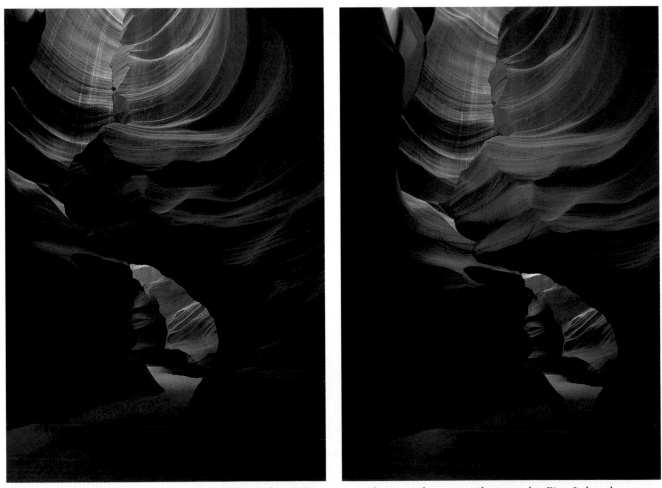

Color-correction is sometimes a matter of personal interpretation, as shown in these cave photographs. First I shot the scene unfiltered (left) and then used a CC20 red filter to achieve what I think is a more natural rendering (right).

Variations in the color content of daylight can be so extreme that even shooting the so-called correctly balanced film doesn't guarantee a correct final image. In this shot my color meter's correction didn't produce what I anticipated, but this very interesting variation on a pink-magenta sky instead. There is always the chance of a surprise when working with filters.

For this photograph of a building, I decided to change the color of the sky by using a CC20 magenta filter.

film outdoors. As discussed earlier they're intended to affect shifts of more than 2000K and fall into two categories, the 85 yellow series and the 80 blue series (see Figure 3-1). When used correctly and under the right circumstances, they should, theoretically, provide the results that would be expected if the correct film were exposed to its designated light source. In practice, however, many photographers find that conversion filters actually produce a result that is a little warmer or cooler than expected, particularly with transparency films. It is very difficult to generalize about this because of the different ways modern films render individual colors. Some films are warmer than others, while others favor hard light and still others favor soft light. Nevertheless, it is definitely worth testing a particular pairing of film and filter before trusting the results as theoretically correct. I suggest you shoot a roll of "converted" film under a variety of lighting conditions appropriate to the Kelvin temperature and then shoot the film without filtration under the light for which it's intended.

The best subject matter for this test is a target composed of a standard gray card, a gray scale, and color patches—all of which are available from any photo store—set against a pure white background, as in a mounting board matched as closely as possible to the white patch on the gray scale. You can also use the white reverse side of another gray card. The fidelity of your colors will be apparent from comparisons of the patches, while the white background will pick up any

FIGURE 3-1. FILTER RECOMMENDATIONS FOR CONVERTING LIGHT SOURCES

Filter Color	Filter Number	Exposure Increase (in *f*-stops)	Change in Temperature (in °K)	Film Change
Blue	80A	2 1/3	3200 to 5500	Type B to daylight
	80B	2	3400 to 5500	Type A to daylight
	80C	1	3800 to 5500	—
	80D	1	4200 to 5500	—
Yellow	85C	1/3	5500 to 3800	—
	85A	2/3	5500 to 3400	Daylight to Type A
	85B	2/3	5500 to 3200	Daylight to Type B

It is good practice to check filter effects through the use of a test chart. This simple one is made up of a Kodak Gray Scale side by side with a white card on which a Kodak Color Control Patches card has been placed. Light readings are taken off the gray card, which is a good indicator of correct exposure.

This Macbeth ColorChecker Color Rendition Chart is very helpful for determining color correction. It contains all the primary additive and subtractive colors, as well as a complete gray scale.

overall color cast. To eliminate exposure as a variable, be sure to bracket the indicated exposure by half a stop over and under, especially with transparency film. Take your light reading directly off the gray card with either a handheld meter or the in-camera meter.

When employing the latter method, focus on the targets first, and then without changing the focus move in until the gray card fills the viewfinder. Be sure not to cast a shadow. The reason for not adjusting the focus when you move in is that when a lens is set below infinity focus, the amount of light reaching the film as indicated by the aperture setting actually decreases the closer you get. This is negligible until you begin to really move in, resulting in possible differences of 1/2 to 1 stop.

Examine your test slides on a color-corrected light table with a Kelvin rating of 5000 degrees. Avoid slide projectors; they don't have the same quality of colored light as a standardized light table. The completeness of the gray scale will be a good indication of correct exposure. If a color cast is present, it will most likely be one that can be characterized as too cool or too warm (i.e., blue versus red). Try viewing the transparency through a light-balancing filter that is the opposite of the unwanted effect. For example, use a warming filter for a slight blue cast. While this isn't the most accurate way to determine a correction, it provides a general indication of how strong the filter should be. Then reshoot with the filter to see the results.

For most general purposes the final images obtained with conversion filters are acceptable. In fact correction filtration greatly depends on the photographer's interpretation. When color outcomes are critical, such as doing copy work, these tests become a standard way to proceed. Here, the light source is usually tungsten, and it is common practice to use converted daylight film. This is fine for noncritical reproduction.

But if color fidelity is a must, you should consider the following guidelines. First, it is most desirable to use the right film for the right illumination instead of converting a film. Second, tungsten bulbs are notorious for shifting color temperature over their burn time. It is better to use quartz bulbs or electronic studio flash. Third, if you copy black-and-white originals, such as photographs, you'll run the risk of picking up a blue cast from the print brighteners used in modern print emulsions. All three cases may require a light-balancing filter (usually a weak warming filter) to fine-tune the film/light-source relationship by between 100K and 200K.

Everyone knows the old adage that rules were made to be broken, and filter use certainly provides its share of examples. As pointed out earlier, you can employ conversion filters to significantly shift Kelvin temperatures for dramatic mood effects. Specifically, using daylight film on an overcast day produces dull, grayish landscapes that appear flat. Using an 80B or, in particular, an 80A tungsten-conversion filter introduces a strong blue cast in the midtones and shadows, leaving the highlights less affected. This gives the appearance of an increase in contrast, but it even more strongly conveys a mysterious mood. My favorite application of this "rule breaker" involves shooting at the seashore when mist or fog is present, to help add an "other-world" look.

Overall, this technique seems to work best on overcast days. When used on a sunny day, it gives the impression that you're using the wrong Kelvin temperature—and obviously not to the scene's advantage. Using a blue 80B or 80A conversion filter also works well with silhouettes, where there is enough illumination in the shadows to allow the blue to come through. These filters increase the cold appearance of snow scenes; again, this seems to be most appropriate on overcast or cloudy days and at sunrise and sunset.

But the last subject you'd want to use a blue 80A or 80B filter on is a white person: Caucasians end up with a pasty complexion, a loss of color in the hair and eyes, and bloodless lips. (However, this effect sometimes works when the subject's clothes and pose reinforce the spiritless, benumbed, and very strange colorations.) The more successful treatments I've seen are monochrome effects; here, viewers concentrate on the facial renderings because the clothing is dark and the background is either light or white, or vice versa.

Using the 85-series filters with human subjects for extreme mood shifts tends to be more appealing because the effect is a strong, reddish-yellow warming. This is very appropriate for late-afternoon, sunset, and

Using daylight film with an 80A filter yields a blue cast that, when used with an appropriate subject, can convey a cool mood as shown here. I photographed this waterfall setting on a heavy-overcast day at a shutter speed of 1 minute.

sunrise shots. As a matter of fact, some photographers use an 85 or 85B filter to enhance their sunsets or sunset landscapes because it is quite acceptable to see orange-cast people, regardless of their true skin color. Dark-complexioned individuals tend to take on a golden glow. Think of some of the sunset advertisements for various tropical islands. Another favorite is a fireplace setting in which flash is employed to fill the main light of the fire, which illuminates the subjects' faces. The 85 conversion filter takes out the blue of the flash and really warms up the fire. When subjects get this warm—or cool with the 80-series filters—I often add a diffuser or soft-focus filter to enhance the mood, giving it a dream-like, ethereal quality.

No filter

Tiffen Haze 2A filter

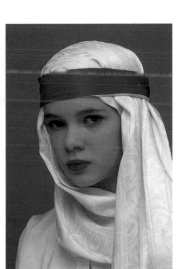

Singh-Ray K UV filter

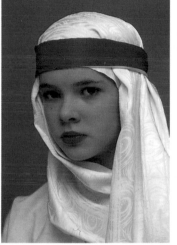

81A filter

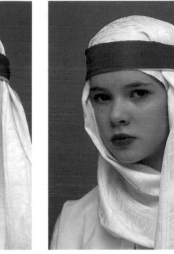

81B filter

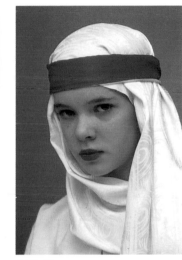

81C filter

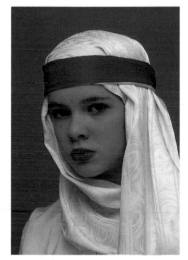

81EF filter

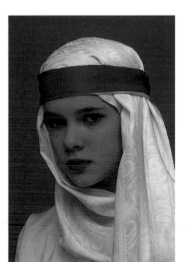

Gold reflectors on either side of model

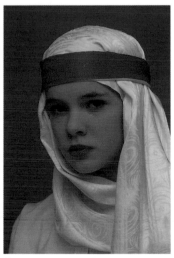

85A conversion filter

Skin tones of lighter-skinned individuals are very sensitive to changes in the color quality of light sources as well as film emulsions. Various filtration techniques solve this problem. For this series of photographs, I shot daylight film with a White Lightning Ultra Strobe balanced for 5500K in a Wafer Plume lightbox and used several different filters and approaches.

LIGHT-BALANCING FILTERS

As discussed earlier, light-balancing filters are a step down from conversion filters in strength, but they produce similar effects. Their primary purpose is to make the refined changes in Kelvin temperature between a film and light source that are sometimes needed. This is a straightforward process based on matching Kelvin temperatures (see Figure 3-2).

Using light-balancing filters to warm or cool a subject is a very popular technique among professional photographers, and I would guess that the 81-yellow-series filters are the most frequently used chromatic filters. There are several reasons for this. First, the effect of these filters is far less than than that of conversion filters; this makes them appropriate in many more situations than the 80- and 85-series filters, which produce heavy changes. The slight warming and cooling effects of the 81 yellow filters are sometimes just subtle enough to create a more pleasing impression, so the viewer picks them up almost unconsciously. Warming and cooling a scene to this extent can, in fact, improve a wide range of subject matter. Some photographers leave a weak warming filter on their lenses to give a certain look to a particular film.

The most commonly chosen light-balancing filters are the weaker 81-series versions; these are used to warm up daylight from later morning to early afternoon and in shady situations where there is an abundance of blue. Following closely behind this application is using them to warm up cool flash shots, which seem to be a typical result of smaller, camera-mounted units. Some photographers choose to mount weak warming gels directly on the flash units. Nevertheless, the principle is the same: Lower the Kelvin temperature by 100K, 200K, or even 300K to make what most people consider to be a more appealing picture.

Sometimes it is necessary to really lower the temperature of deep shade or midday sun with one of the strongest filters in this series, an 81EF or even an 85B conversion filter (see Figure 3-3). But most of the time the weaker versions are sufficient. How do you know which strengths are needed? Some photographers make their decisions based on experience, while those who don't want to leave anything to chance rely on the help of a color meter.

FIGURE 3-2. LIGHT-BALANCING-FILTER RECOMMENDATIONS FOR FINE ADJUSTMENTS OF COLOR BALANCE

Filter Color	Filter Number	To obtain 3200K from:	To obtain 3400K from:	Exposure Increase (in f-stops)
Bluish	82C + 82C	2490K	2610K	$1 \frac{1}{3}$
	82C + 82B	2570K	2700K	$1 \frac{1}{3}$
	82C + 82A	2650K	2780K	1
	82C + 82	2720K	2870K	1
	82C	2800K	2950K	$\frac{2}{3}$
	82B	2900K	3060K	$\frac{2}{3}$
	82A	3000K	3180K	$\frac{1}{3}$
	82	3100K	3290K	$\frac{1}{3}$
	No Filter Necessary	3200K	3400K	
Yellowish	81	3300K	3510K	$\frac{1}{3}$
	81A	3400K	3630K	$\frac{1}{3}$
	81B	3500K	3740K	$\frac{1}{3}$
	81C	3600K	3850K	$\frac{1}{3}$
	81D	3700K	3970K	$\frac{2}{3}$
	81EF	3850K	4140K	$\frac{2}{3}$

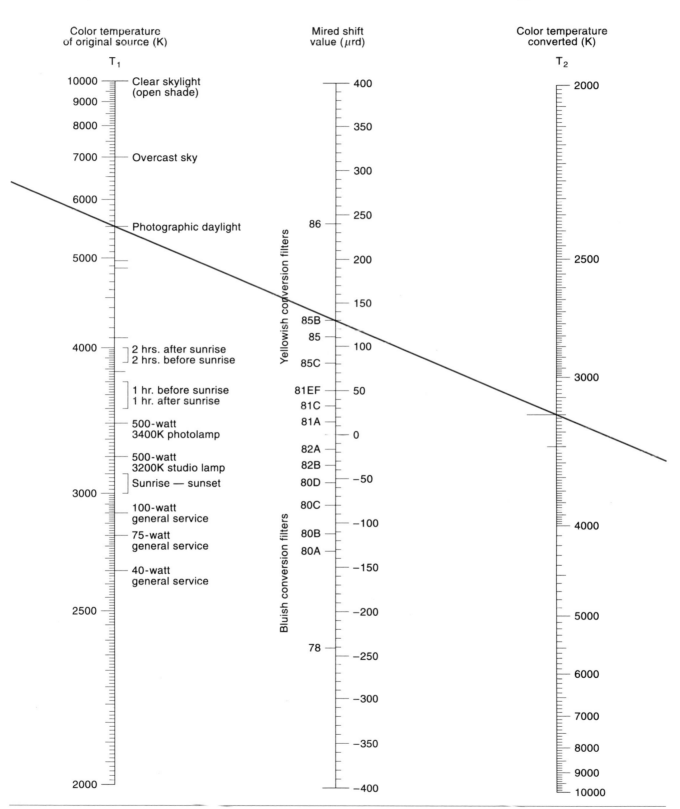

To convert a light source from one color temperature to another, lay a straight edge across the color temperature of the original source and the conversion color temperature, as illustrated above. Here, for example, converting a 5500K source to 3200K requires an 85B filter for a shift of 130 mired.

COLOR METERS AND CLIP TESTS

Color meters work on the principle of directly measuring at least two of the primary additive colors and calculating for the third. The more expensive models check all three additives. Some can handle only daylight, and others only flash; again, the more expensive ones can deal with virtually all sources. Once a simple measurement is taken, the meter gives a value that you then use to find the corrective filtration on a scale or table. And, not surprisingly, the very expensive models make this calculation for you. Many color meters supply the *mired value*. "Mired" is an abbreviation for *micro reciprocal degrees*. This number comes from dividing the color temperature by one million. Mireds are an alternative way of correcting for color temperature (see Figure 3-3 to see how these relate to the more commonly used Kelvin scale).

The use of color meters by photographers is limited, primarily because of their expense: some cost as much as a sophisticated electronic SLR camera and lens. Also, many photographers quickly learn when a scene needs warming or cooling. These meters are, however, indispensable to those who must know the mix of Kelvin degrees and color, such as in critical studio or field setups where postproduction correction of the image isn't a viable option.

When you reach this level of control, your work may include *clip testing* as well. Here, you shoot a roll of a lighting setup and send it out for processing. The lab "clips" a small portion of the film according to your instructions and processes it. Then you evaluate

the results and make any necessary adjustments before processing the rest of the roll. Once the standard is established, you then complete the shoot with film with that same batch number. When the results show some variation in the rendering of color, you can use warming, cooling, and CC filters to correct the difference.

Photographers don't use the 82-cooling-series filters as frequently as their 81-series counterparts, no doubt because of the bias toward the warmer, yellow-red colors more readily associated with the more pleasurable emotions. Nevertheless, cooling filters do have their uses. For example, an 82-series filter is helpful when you want normal color rendering at sunset or under warmed-up light sources, which often occurs when daylight reflects off a brightly colored red or yellow wall. You can also employ these filters to remove the excessive blue in a snow scene or to "cool down" any subject that should be rendered this way, including icicles, a frozen lake, a waterfall in a snow setting, or blue post-sunset light. Remember, sunlight becomes progressively redder until sunset, then the light becomes bluer until it disappears.

COLOR-COMPENSATING FILTERS

CC filters extend the principle of subtractive color correction beyond the general warming and cooling effects of conversion and balancing to control individual colors (see Figure 3-4). In fact, the weaker warming and cooling filters have their counterparts among the yellow, orange, and blue CC filters (see Figure 3-6). Once again the idea is usually to achieve as correct a rendering as possible. Photographers use them most frequently to fine-tune two types of illumination. In a controlled, standardized lighting situation, the need to correct color comes from variations in the film's response to the illumination, such as a studio strobe. Shooting under *nonstandardized lighting,* such as fluorescent light, requires contending with too much of a particular color in the light source itself; here, there is an abundance of green (see page 63). A variation of the film response scenario also occurs when long shutter speeds are used in time exposures. In these situations the film's normal response curve is altered, so that it fails to properly record colors.

Still, when photographers are able to control the light source and environmental light modifiers, such as reflectors, the result isn't always a "perfect picture." Even the most critically controlled manufacture of film,

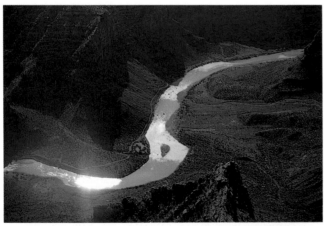

Shooting through manmade materials, such as the tinted Plexiglas of a plane window, often results in a color cast over the entire picture and lower contrast. You can either select high-contrast subjects to offset the loss of contrast, as shown here, or use complementary color-compensating filters to help eliminate the chromatic effect.

FIGURE 3-4. COLOR-COMPENSATING-FILTER RECOMMENDATIONS FOR COLOR CORRECTION

Density	Tiffen Color-Compensating Filters					
	Red (Absorbs Blue and Green)	Exposure Increase* (in *f*-stops)	Green (Absorbs Blue and Red)	Exposure Increase* (in *f*-stops)	Blue (Absorbs Red and Green)	Exposure Increase* (in *f*-stops)
.025	(CC025R)**	—	(CC025G)	—	(CC025B)	—
.05	CC05R	$1/3$	CC05G	$1/3$	(C05B)	$1/3$
.10	CC10R	$1/3$	CC10G	$1/3$	CC10B	$1/3$
.20	CC20R	$1/3$	CC20G	$1/3$	CC20B	$2/3$
.30	CC30R	$2/3$	CC30G	$2/3$	(CC30B)	$2/3$
.40	CC40R	$2/3$	CC40G	$2/3$	(CC40B)	1
.50	CC50R	1	CC50G	1	CC50B	$1\,1/3$
Density	Yellow (Absorbs Blue)	Exposure Increase* (in *f*-stops)	Magenta (Absorbs Green)	Exposure Increase* (in *f*-stops)	Cyan (Absorbs Red)	Exposure Increase* (in *f*-stops)
.025	(CC025Y)	—	(CC025M)	—	(CC025)	—
.05	CC05Y	—	CC05M	$1/3$	CC05C	$1/3$
.10	CC10Y	$1/3$	CC10M	$1/3$	(CC10C)	$1/3$
.20	CC20Y	$1/3$	CC20M	$1/3$	(CC20C)	$1/3$
.30	CC30Y	$1/3$	CC30M	$2/3$	(CC30C)	$2/3$
.40	CC40Y	$1/3$	CC40M	$2/3$	(CC40C)	$2/3$
.50	CC50Y	$2/3$	CC50M	$2/3$	CC50C	1
.70	CC70Y	$2/3$***	CC70M	$1\,2/3$***	—	—
.90	CC90Y	$2/3$***	CC90M	2***	—	—
1.10	CC110Y	$2/3$***	CC110M	$2\,1/3$***	CC110C	2***

* For critical work, exposure compensation should be checked by practical test.
** Filters indicated in parentheses are available only as gelatin cemented between glass.
*** New test results.

reflectors, and lenses won't always produce clean colors. This is particularly true in the case of so-called neutrals, such as in reflections off metallic surfaces. These are notorious for revealing "color contamination" in film, light sources, and light modifiers, such as picking up the hue of other colors used in the setup. Large, neutral areas are another problem. For example, white seamless paper is infamous for showing color casts, especially in shadow areas. In addition to these litmus effects on neutrals, you often need to "punch up" or "play down" a dominant color in a shot, such as the green in a product label.

If the correction is limited to eliminating a color cast in neutral areas and you notice it before shooting,

you can then employ a set of CC *viewing filters* to see which ones will remove the unwanted wavelengths. You can use CP filters, which are ordinarily used in the color darkroom for print analysis, to evaluate the balance within the scene itself. Since you can purchase these filters in sets of three densities of each color per card, you can easily see changes over a range of strengths. This also prevents you from handling delicate CC camera gels, which, of course, you can also use.

An acknowledged pitfall of this on-the-spot form of evaluation is the tendency to overcorrect. There is no physiological explanation for this; photographers can see small differences in color but don't necessarily know precisely how much these variances amount to.

For example, a photographer might choose a .10 yellow filter instead of a .05 or even a .025 filter, either of which would be adequate. This becomes a matter of practice confirmed by careful examination of results, or is simplified via the use of a color meter. Another procedure to follow is to avoid whenever possible combining two separate filters to color-correct. For example, if the additive primaries red and green are called for in approximately equal amounts, you would use the subtractive primary cyan because it's composed of both of these colors.

Employing CC filters to correct for unusual light sources, especially fluorescent light, is probably what photographers most frequently use these filters for. So prevalent is this difficult problem that some manufacturers have put out a special fluorescent filter that's based on the subtractive color principle. In fact I've never met a photographer working in color who didn't hate fluorescent lighting because it is a nonstandardized light source.

What do I mean by "nonstandard"? Unlike white light with its continuous spectrum, fluorescent tubes

Magenta filters effectively eliminate the green of fluorescent lighting indoors and out. You can see how different the green flood lights of this building look when photographed unfiltered (right) and with a CC40 magenta filter (below).

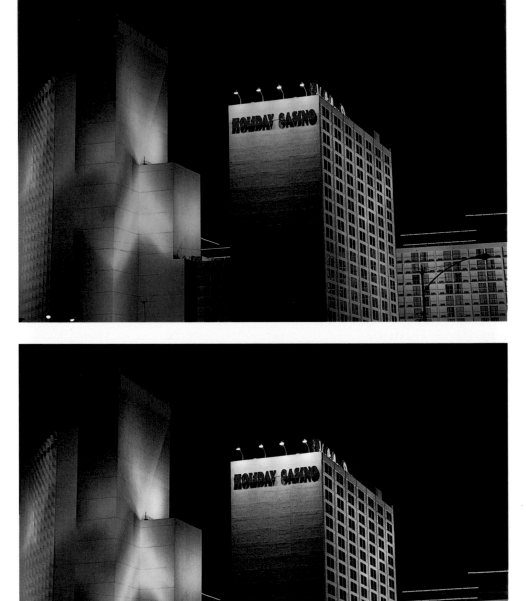

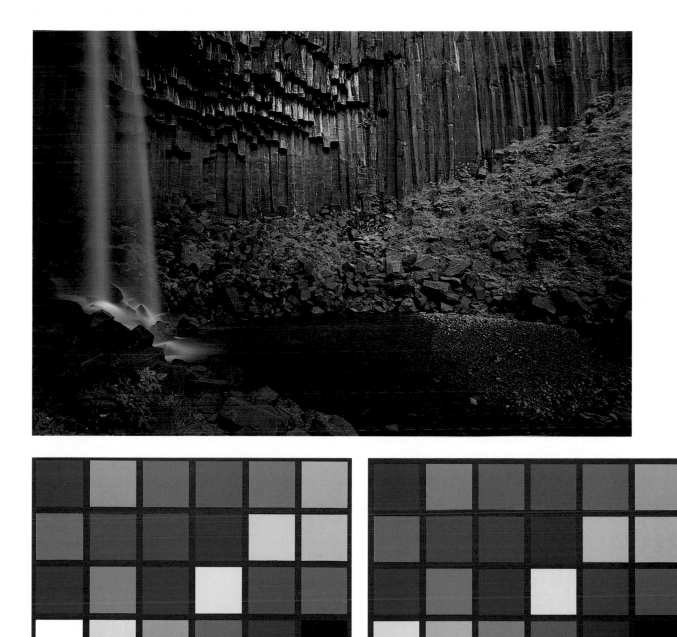

You can also use CC filters when the subject is in low light surrounded by a monochromatic setting. For this serene shot of a waterfall, which was in an outcropping of dark rock, I chose a CC20 green filter to "lift" the green color of the plants to give the scene more chromatic contrast (top). I used a very slow shutter speed of 6 minutes, so that the white water would show a color shift due to the long exposure. The Macbeth ColorChecker (bottom left) received the same CC20 red filtration (bottom right).

have a discontinuous spectrum of color. This produces a difference in the proportions of the colors present. Despite these differences, manufacturers use such terms as "daylight" to describe their products and rate them by Kelvin degrees; however, this isn't very helpful to photographers looking for critical color reproduction. A more useful scale for rating fluorescent light is the *Color Rendering Index,* or *CRI,* which uses daylight (the light at noon) as a standard with a top rating of 100. So, for example, a Vita-Lite tube rated at

CRI 91 has 91 percent color accuracy when compared to daylight. The higher the CRI, the more correct the color rendering.

How, then, do you deal with these conditions? In other words, how do you find a filter that works on the majority of fluorescent tubes being used today? The broadest category that most photographers encounter when working with this light source is the cool versus warm fluorescents. Just a glance at a ceiling fixture shows either a

FIGURE 3-5. FILTER RECOMMENDATIONS FOR FLUORESCENT LIGHTING AND HIGH-INTENSITY DISCHARGE LIGHTING

Fluorescent Lamp	Kodak Color Film			
	All Kodacolor*, Vericolor HC Professional, Vericolor III Professional, Type S	All Ektachrome (Daylight), all Kodachrome (Daylight)	All Ektachrome (Tungsten), Vericolor II Professional, Type L	Kodachrome 40 5070 (Type A)
Daylight	40M*** + 40Y + 1 stop	50M + 50Y + 1 1/3 stops	No. 85B + 40M + 30Y + 1 2/3 stops	No. 85 + 40M + 40Y + 1 2/3 stops
White	20C + 30M + 1 stop	40M + 2/3 stop	60M + 50Y + 1 2/3 stops	40M + 30Y + 1 stop
Warm White	40C + 40M + 1 1/3 stops	20C + 40M + 1 stop	50M + 40Y + 1 stop	30M + 20Y + 1 stop
Warm White Deluxe	60C + 30M + 2 stops	60C + 30M + 2 stops	10M + 10Y + 2/3 stop	No filter No exposure adjustment
Cool White	30M + 2/3 stop	40M + 10Y + 1 stop	10R + 50M + 50Y + 1 2/3 stops	50M + 50Y + 1 1/3 stops
Cool White Deluxe	20C + 10M + 2/3 stop	20C + 10M + 2/3 stop	20M + 40Y + 2/3 stop	10M + 30Y + 2/3 stop
Unknown Fluorescent**	10C + 20M + 2/3 stop	30M + 2/3 stop	50M + 50Y + 1 1/3 stops	40M + 40Y + 1 stop

* For critical use with Kodacolor VR-G 400 and VR 1000 films.

** When you don't know the type of fluorescent lamps, try the filter and exposure adjustment given; color rendition will be less than optimum.

High-Intensity Discharge Lamp	Kodak Color Film			
	All Kodacolor*, Vericolor HC Professional, Vericolor III Professional, Type S	All Ektachrome (Daylight), all Kodachrome (Daylight)	All Ektachrome (Tungsten), Vericolor II Professional, Type L	Kodachrome 40 5070 (Type A)
General Electric Lucalox **	70B + 50C + 3 stops	80B + 20C + 2 1/3 stops	50M + 20C + 1 stop	55M + 50C + 2 stops
General Electric Multi-vapor	30M + 10Y + 1 stop	40M + 20Y + 1 stop	60R + 20Y + 1 2/3 stops	50R + 10Y + 1 1/3 stops
Deluxe White Mercury	40M + 20Y + 1 stop	60M + 30Y + 1 1/3 stops	70R + 10Y + 1 2/3 stops	50R + 10Y + 1 1/3 stops
Clear Mercury	50R + 30M + 30Y + 2 stops	50R + 20M + 20Y + 1 2/3 stops **	90R + 40Y + 2 stops	90R + 40Y + 2 stops

* Consult the manufacturer of high-intensity discharge lamps for ventilation and safety information.

** This is a high-pressure sodium-vapor lamp. The information in the table may not apply to other manufacturers' high-pressure sodium-vapor lamps because of differences in spectral characteristics.

*** Abbreviations for colors: M = magenta, Y = yellow, C = cyan, R = red.
 Courtesy of G.E. Lighting, Nela Park, Cleveland, OH.

Many manufacturers now offer specialized fluorescent correction filters balanced for daylight or tungsten films. These filters can be effective in removing the green cast in common fluorescent lighting. They represent a single filter alternative to the specific corrections listed in Figure 3-5. In addition, color-correcting magenta filters in strengths between 20 and 30 work very well as shown in this shot made with Kodak E 100 SW transparency film (left).

FIGURE 3-6. EQUIVALENTS BETWEEN LIGHT-BALANCING AND COLOR-COMPENSATING FILTERS

Filter	Color	Equivalent CC* Values
80A	Blue	90 cyan + 30 magenta
80B	Blue	80 cyan + 25 magenta
80C	Blue	55 cyan + 17 magenta
80D	Blue	35 cyan + 12 magenta
81	Yellow	05 yellow
81A	Yellow	05 yellow + 02 magenta
81B	Yellow	10 yellow + 02 magenta
81C	Yellow	15 yellow + 05 magenta
81D	Yellow	25 yellow + 07 magenta
82	Blue	10 cyan + 05 magenta
82A	Blue	15 cyan + 05 magenta
82B	Blue	20 cyan + 07 magenta
82C	Blue	25 cyan + 07 magenta
85	Orange	55 yellow + 20 magenta
85B	Orange	65 yellow + 22 magenta
85C	Orange	35 yellow + 10 magenta

* Color-compensating.

bluish or pinkish cast, tipping you off to its nature. Under either cool or warm light, unfiltered daylight film yields a strong green cast, and tungsten-treated emulsions display a strong blue. The effect on other colors varies; using the test-card setup described earlier in the chapter provides more information and helps you determine which filter works best. If you have time to pre-test before shooting, photograph the test card with various types of filtration that you think might work. Later try to further correct your best slides by viewing them with CP filtration, and apply these results to the actual shoot.

Several lighting-equipment manufacturers, including Kodak, publish corrective tables (see Figure 3-5). While this particular data is intended for only Kodak films, I've found the recommendations useful starting points for both Agfa, Fuji, and other emulsions. A good tip is to not use shutter speeds faster than 1/60 sec. since fluorescent light actually

comes from a gas-filled tube that is electrically charged, producing a source prone to flickering. Slower shutter speeds, then, even out the possible effect of flicker on color distribution.

ARCHITECTURAL AND INDUSTRIAL PHOTOGRAPHY

When complete control of lighting is required, as with architectural photography, existing fluorescent tubes are sometimes replaced with others for which a film-filter combination has been worked out. Industrial and architectural photographers continually face this problem of unusual light sources as well as mixed sources. Suppose that you are about to photograph a building against an early-evening sky. You see that the offices have fluorescent light and that the exterior is illuminated and highlighted with tungsten spotlights. This scene contains three or four different sources: daylight, warm light (just before sunset) or cool light (just after sunset), fluorescent light, and tungsten light. What do you do in such a situation?

Sometimes correcting for a particular color causes it to reappear in another light source. When I used a CC30 magenta filter, the upper office building's fluorescent lights appeared white but the lights in the walkway shifted to green.

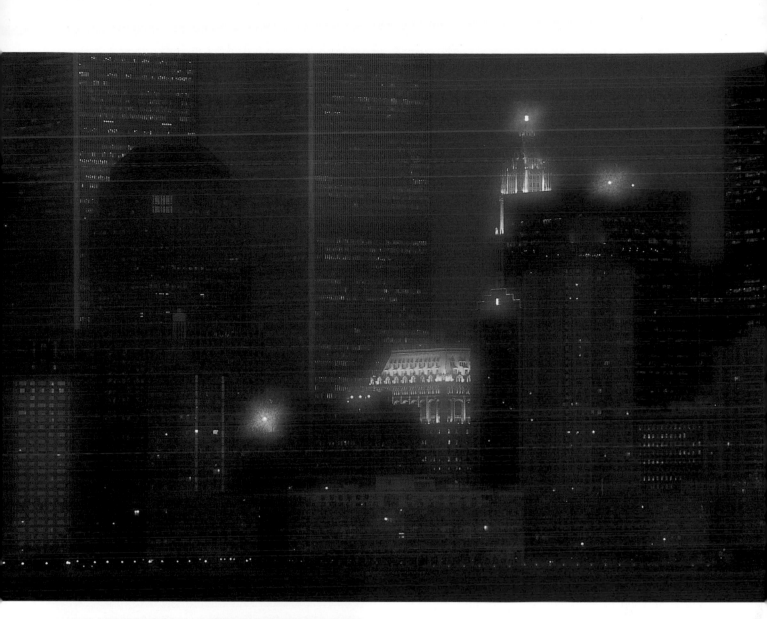

Working with mixed lighting means making compromises in filtration. For this skyline shot at dusk, I used a CC20 magenta filter to give the sky more color and to hold back some of the green from the fluorescent lighting in the office buildings. I added a Nikon Soft II filter to achieve the halo effect.

Sometimes a photographer faces light sources that lack certain wavelengths, such as sodium vapor. The solution is to filter the subject directly in the absence of other sources. For this shot, an industrial photographer filtered the sodium-vapor work lights with a special sodium-vapor filter from Singh-Ray. Note the color of the daylight in the upper right corner. (Courtesy of Viron Barbay, Lufkin Industries)

Architectural and industrial photographers continually face the problem of mixed and unusual light sources in a scene. In the three photographs an architectural photographer adjusted for mixed lighting by combining multiple exposure and filtration. First the lights were turned off, and daylight film was exposed for the sky and building (left). Later in

the evening when daylight was no longer a factor, the lights were turned on and a second exposure with a CC30 magenta filter was made (right). The final image shows warm, white fluorescent light and a pleasant, warm tungsten light reflected in the water (opposite page). (Courtesy of Harrison Northcutt)

In many cases the solution is a photograph taken in three exposures on one frame of film, each with different filter packs. First, you work out a correct filtration for each light source. In the case of daylight this might not require any filtration if you use daylight film, or you might need to add only a minor enhancement of the early-evening effect with, for example, a CC20 magenta filter. Next, you take the three photographs in the following sequence, with meter readings divided over the three multiple exposures for a correct overall exposure. For the first exposure, you shoot the building with all lights turned off during the early evening on daylight film. Once the sky darkens and the fluorescent lights are turned on, you make a second exposure through a filter pack previously tested for this light source on daylight film. After these lights are shut off and the exterior tungsten lights are turned on, you make the final exposure through the filter pack designed for them. The result is clean, white, artificial lighting within a warm-sunset landscape.

You can often make interior shots the same way. First, you shoot with all the lights off to record only the daylight coming in the office windows. Next, you

shoot at night with the overhead fluorescents on, and then perhaps with the tungsten desk lamps on, all properly and separately filtered. In environments where you can turn off only some or perhaps even none of the mixed lighting, you have to rely on mixed filtration and compromises, giving the highest level of correction to the most dominant sources. Photographers frequently employ Polaroid instant film to assist them in such situations in order to see a general indication of a filter's effect.

CONTROLLING CONTRAST

As discussed earlier, contrast in color photography is a function of many factors, all based on establishing some noticeable difference within the color elements. When looking to chromatic filters to control contrast, you have three choices. You can intensify colors through saturation or tone down individual colors with tint changes or pastel effects, all of which can be done to one degree or another by using CC filters. You can also change the mood through warming or cooling, which frequently reduces contrast. The third

option is to introduce color in large portions of an image via graduated color filtration that provides contrast to the other colors.

CC filters can take the principle of color correction a step further because the filtration accents an individual color. Sunsets are a good example. Typically the sky is so alive with color and light that it can overwhelm or at least compete with the sun. Then there are times when the sky's color is quite dull; it can even be white or light gray, such as in overcast conditions, and at the same time the color of the sun dominates. Introducing a warm sunset color into the dull sky will even out the discrepancy between the sun and the sky. And desert sand against a pale blue sky can be altered so that the sand picks up a reddish color and the blue of the sky is darkened.

Adding chromatic contrast to a scene is often a matter of arranging subject matter to reinforce the filtration. Here, shooting just before sundown I took advantage of the glare in the windows to serve as a contrast to the building itself, and introducing an 81EF warming filter produced an overall warm effect in an otherwise very contrasty setting.

Low chromatic contrast in a scene is also a problem. By arranging to have the railing in the center of the image and coloring it with a CC15 magenta filter, I was able to blend the components with color instead of having a stark white railing stand out in the foreground (left). This "moonscape" was produced in daylight via the combination of a CC40 red filter with a graduated mauve filter (opposite page).

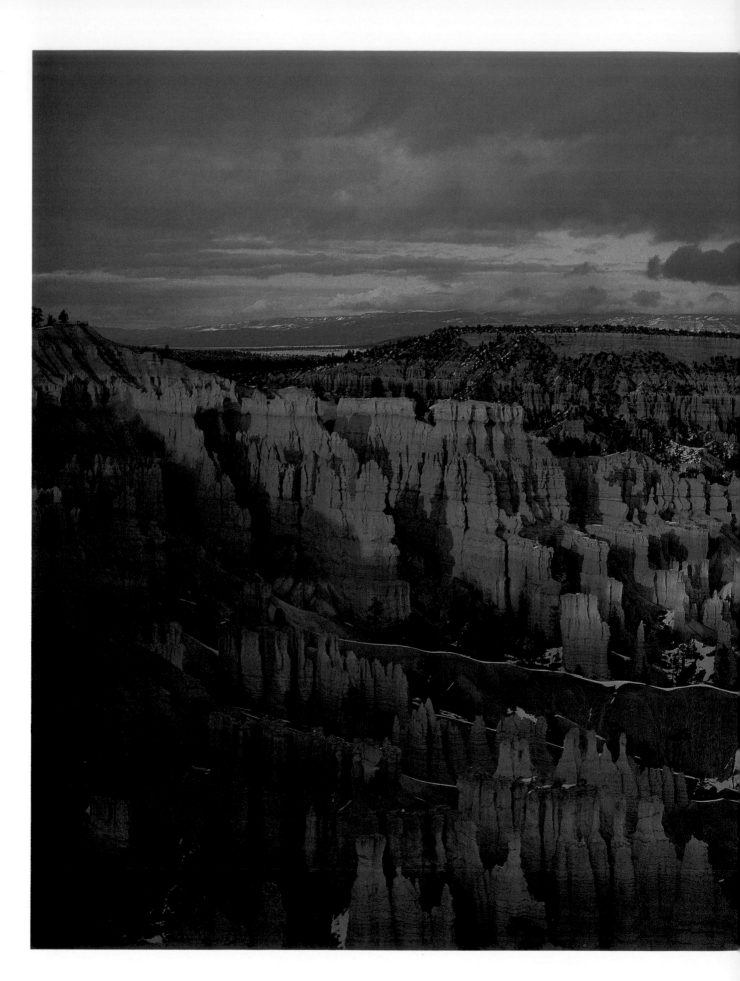

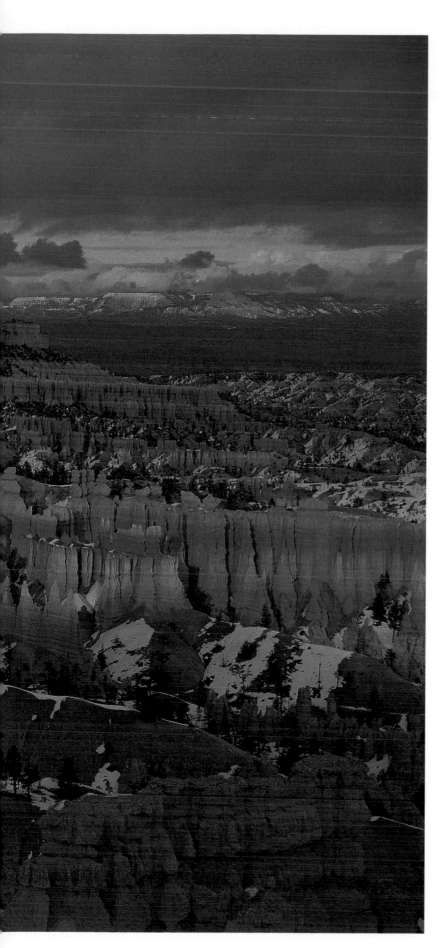

Snow scenes on cloudy days tend to appear muddy gray, almost monochrome. The 82-series filters with their cool blue look help to alleviate the gloom. For this majestic vista, I used an 82B filter and a graduated light-mauve filter in the sky area.

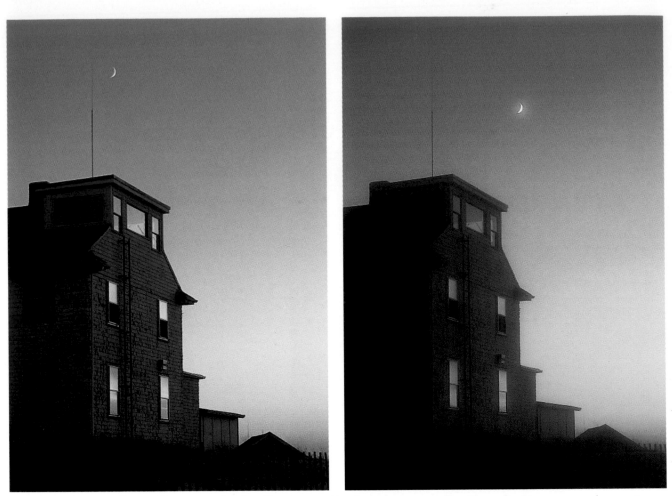

One of the keys to effective filter use with color films is to realize that you can usually affect a final image several ways. In these examples, I obtained a cool treatment in one photograph through the use of an 80A filter (left), and produced a warm treatment by combining an 81D filter and a Tiffen Soft FX3 filter (right).

These two complementary colors are now stronger (more saturated) and actually clash, producing increased contrast. In both cases the effect is achieved with a magenta filter. In the sunset shot, the magenta filter increases the blue of the sky and the red of the sun; in the desert shot, combining the magenta filter with a warming filter, such as an 81A, enhances the red of the sand.

Many filter effects on contrast go beyond what I've been referring to as correction and into the realm of creative usage. It is very difficult to quantify contrast manipulation because of the complex nature of color. The degree of change more or less dictates whether the motivation is for corrective or creative purposes.

As discussed earlier, light-balancing and conversion filters can create or alter a mood by producing shifts in Kelvin temperatures. Not only does this result in a range of cool and warm color shifts, but also an overall lowering of contrast by virtue of moderate to strong color casts. In that sense the color itself is the

mood—blue, for example—subduing all other colors and in the case of conversion filters, even removing them entirely.

Graduated filters introduce color in areas that often lack any color, such as overcast or cloudy skies and areas of water in a foreground. The idea is to select a color that is compatible with that part of the image, such as a blue or red-orange for the sky and green or blue for water; this adds chromatic contrast. These filters now come in a variety of hues and strengths and are available in square or circular designs. You can choose the single type of graduated filter that has either a definite line of demarcation between the color and clear areas or a more gradual separation, or the continuous type in which the color is very strong at one end and decreases to a lighter hue at the other end. Photographers often combine two graduated filters to produce different effects in the upper and lower portions of an image. Many dull landscapes have received a much-needed boost in color contrast thanks to these useful filters.

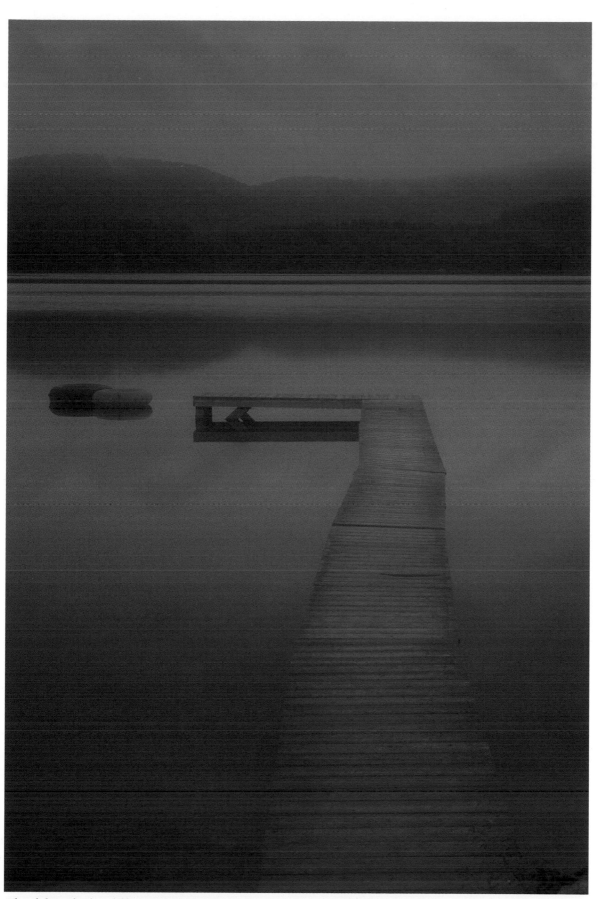

The ability of colored filters to build up chromatic contrast in very flat, blue-gray light conditions is demonstrated here by the use of an 81EF warming filter with a tobacco graduated filter in the sky on a heavy-overcast day.

USING CHROMATIC FILTERS DESIGNED FOR BLACK-AND-WHITE FILM WITH COLOR FILM

Another class of contrast filters is customarily used with black-and-white films to control the translation of colors into various gray tones. These are the yellow, orange, green, red, and blue filters, which are listed from strong to moderate to light according to their density numbers (see Figure 4-2). If you use these filters with color film, they'll cause a very strong, overall color in your final photographs. Usually this effect isn't desirable because it produces neither real nor believable colors. In fact as you continue to experiment with filters, you'll find that this effect tends to work only when the cast is acceptable in relation to a mood effect or the color of the subject supports the cast, much the same way that conversion filters affect mood. For example, you can produce a mono-color image with black forms

The translation of specific colors to tones of black and white can be significantly altered via chromatic filters intended for use with black-and-white films as seen here. This enables the photographer to alter contrast and tonal separation. In this series of pictures of the bottom two lines of the Macbeth ColorChecker chart, the gray scale on the bottom line appears the same for all filters and was used to ensure uniform exposure when each black-and-white print was made. The line containing blue, green, red, yellow, magenta, and cyan changes gives you some idea of how contrast between colors in a scene can be altered with the most commonly used chromatic filters.

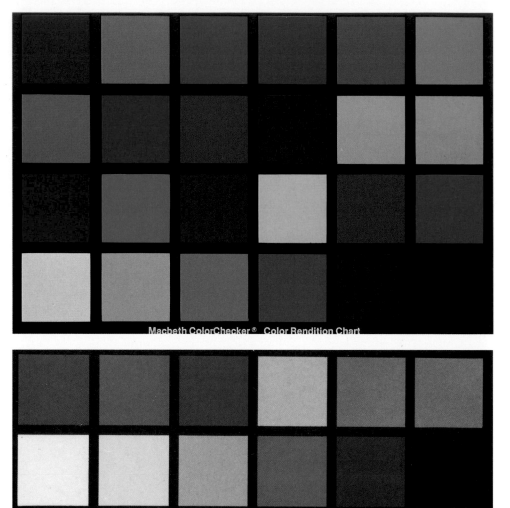

No filter

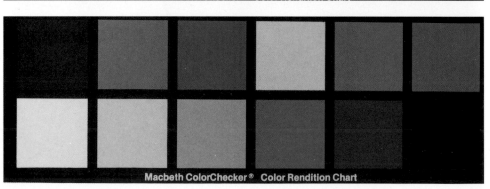

8 Yellow filter

and shapes. The best example is the *silhouette*, in which color can play a dramatic role highlighting the lighter parts of the scene. Another application is to convert a full-tone scene into a mono-color image, relying on textures and details within the subject to create a strong image and to elicit interest. Try shooting the veins of a leaf in extreme closeup with a 58 green filter or a man dressed in motorcycle leathers standing against a brick wall with a 25 red filter. In both cases,

the filter selection adds some validity to the subjects since a leaf is usually green and bricks are red.

This same idea works when a 12 deep yellow filter or a 21 orange filter is used for a sunset shot to enhance the effect of the sun's warm presence. Of course, using chromatic filters designed for black-and-white film with color film is a heavyhanded approach to color, but there are times when the results are clearly successful.

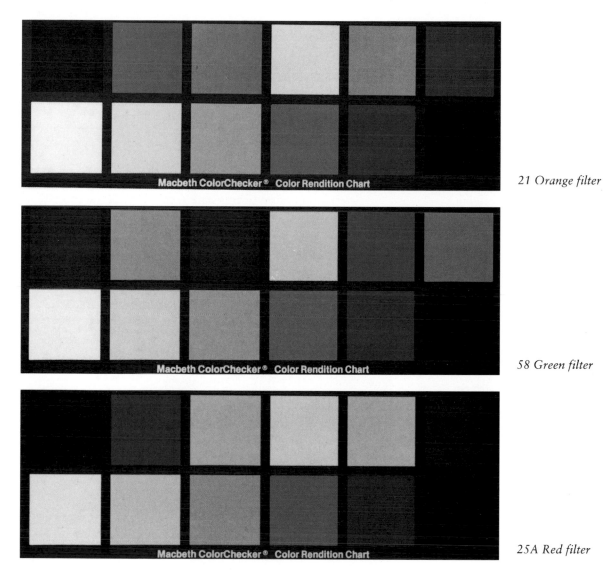

21 Orange filter

58 Green filter

25A Red filter

USING CHROMATIC FILTERS WITH BLACK-AND-WHITE FILM

When it comes to black-and-white film, many photographers devote their attention to controlling the relationship between exposure and development in order to capture the brightness range of a scene on film. They rely on the darkroom manipulations of different paper grades to change contrast; to add light to areas they wish to darken, which is called *burning in;* and to hold back light from parts of the print that are too dark, which is called *dodging.*

What many photographers fail to exploit is the ability of chromatic filters to control how colors and certain subject matter, such as water and the sky, are translated into tones on the gray scale. It sounds odd to say that when photographers work with monochrome materials, they should think in terms of color as well as black and white. Nevertheless, this is true. And, what's more, it is critical for photographers to use this dual mindset to translate scenes with correct tonal

If camera filtration isn't used in black-and-white photography, photographers often have to fall back on burning in, as shown here, and dodging. The background received extra exposure because I was unable to filter it when making the picture. I also had to burn in the sweater and add shadows to the subject's face. A green filter would've darkened his rose-magenta colored sweater and rendered his skin tone and the blue dots on his hat more naturally.

Some high-contrast films aren't sensitive to all visible colors. These films are often used to produce black-and-white images with extremely high contrast, such as this graphic-design shot.

representations, or to translate scene into ones that they want to depict for some creative purpose.

Given these conditions, you need to know: how proper filtration can lead to a more pleasing rendition of a subject, how filters ensure appropriate separation of various colors in the final print, and how you can alter the "natural" look of a scene to produce more dramatic or extreme effects. In all shooting situations, though, you shouldn't confuse the effects of the filters with the influence of light itself on shadows, highlights, and midtones. For example, a small light source produces harsh shadows, and backlighting causes strong highlights. All you have to be concerned with is how you can affect the color content of the light and, therefore, the way the tones of gray appear in the final print, especially in the midtone areas. (See Chapter 5 to learn how nonchromatic filters alter the non-color light attributes of black-and-white photography that are more likely to influence highlight and shadow areas.)

BLACK-AND-WHITE FILMS

Various types of black-and-white films are available. The most common is *panchromatic film*. The chemicals in the film's emulsion are sensitive to literally all colors. Unfortunately this doesn't mean the chemicals are sensitive to *only* colored white light, and to all colors *equally*. Actually panchromatic films, such as Kodak T-Max, Kodak Tri-X, the various Agfapan emulsions, Fuji's Neopan, and Ilford's HP-5 Plus, are also affected by UV radiation. UV light lies right next to white light, just outside the range of visible light on the electromagnetic spectrum. Film can see and react to it, but you can't. So you have to be aware of situations in which UV light is present in order to deal with it; you'll encounter UV light in atmospheric haze and blue skies. (Certain clear, nonchromatic filters can block UV light; see Chapter 5.)

Panchromatic film's unequal sensitivity to all colors is, however, an important concern. Ideally the

Infrared films record scenes differently because they are sensitive to wavelengths beyond those in the visible spectrum and require very strong red filtration. (Courtesy of Peter Klose)

translation of a color to a tone of gray should be proportional to the brightness of the color and, therefore, the amount of light it reflects. For example, light green should show up as a very light gray on the gray scale, and deep blue a much darker shade. The mechanics of how this actually happens depend on how much light of each color reaches the negative. The more light that hits the emulsion, the greater the chemical reaction. The result is a denser area that holds back the light of the enlarger, making a correspondingly lighter area in the print.

In a theoretically perfect situation, the amount of green light reflected from a light green object is larger than that from a dark blue object and produces a denser area on the negative than the light reflected from the blue object. In the real world, however, many panchromatic films have about the same sensitivity to the additive primaries of red and green but are more

sensitive to blue, violet, and, incidentally, ultraviolet. So it is possible that light green and dark blue will have little separation since the emulsion reacts more to the blue end of the spectrum. The situation is complicated even further by the nature of the light sources themselves. For example, tungsten bulbs give off much more red than 5500K daylight does.

By now you're probably wondering how you were ever able to get good black-and-white photographs without filters, since there are so many complicating variables. The fact is, you certainly can get good monochrome images without filtration, just as you can make a color picture of an outdoor scene with tungsten film. If your subject is appropriate, the color mismatch may not be noticeable, especially if you shoot around sundown, or it may even improve the rendering. Nevertheless most of the time that photographers shoot tungsten film outside, they see

and are distracted by the incorrect matchup between film and light, simply because human beings are used to seeing everything in color.

Similarly photographers spend very little time viewing monochrome images, so their level of experience and sophistication with this medium is limited. This becomes obvious when they're impressed by the work of a master black-and-white photographer. They're inspired not only by the visual content of the images, but also by the tonal rendering: rich blacks, brilliant whites, and, above all, details of the print separated out through a whole range of grays. Inexperienced observers often attribute these qualities to a "good printer" or the types of film, paper, and developer used (see page 92). More likely, the photographer used his or her understanding of light and filtration when making the picture. Even revered photographer Ansel Adams relied on colored filters to

Besides varying exposure and development, the primary mechanisms for controlling tone and contrast in black-and-white photography are using camera filters and altering the contrast grade of the printing paper. Both the separation and contrast between this red building and the sky were influenced by the use of filters. Unfiltered the building appears moderately dark against a light-gray sky (right). Then I used a 23A red filter to lighten the building in the sunlight (center) but it darkened the sky. So then I switched to a 47 blue filter that rendered the building almost black and the sky white (bottom).

properly translate and separate the tones of gray in his subjects—and few would challenge the assertion that he set very high standards for print quality.

The first step to having greater control over the translation of color to monochrome is to know how this change takes place without filters (see Figure 2-4). Once you have a grasp of which colors produce which tones, the next step is to see how chromatic filters change this process. As I've pointed out, the rules are the same as for color photography: A filter produces a lighter tone of gray than normal for light rays of its own color, and it transmits that particular color while blocking all others either partially or completely (see Figure 4-1). Specifically if a color is blocked, the amount of light reaching the negative in that area will be less; this in turn will allow more light to pass when the negative is placed in an enlarger. In the case of total blockage, the developed negative will show a clear area. The result in both cases is a darker rendering. Once again the complementary colors are blocked most, so they appear darkest. You then have to compensate for this light loss by adjusting exposure according to a filter factor. Use the color wheel to identify the relative nature of the complementary colors (see Figure 1-3).

While these conditions apply to all chromatic filters, the effect of some filters on black-and-white images is so minimal that it is hardly noticeable. This includes all of the very weak CC and light-balancing filters. The filters designed for black-and-white work are specific to that medium, and their colors—red, orange, yellow,

Filters intended for use with black-and-white film have strong colors that block wavelengths sufficiently enough to produce shifts in the gray tones. The most commonly used filters are the 21 orange, 25A red, 11 green, 47 blue, and 8 yellow filters (left to right).

FIGURE 4-1. CHROMATIC-FILTER RECOMMENDATIONS FOR PANCHROMATIC FILMS

Filter Color	Filter Number*	Filter Factors**	
		Daylight Film	Tungsten Film
Light yellow	6 (K1)	1.6X ($^2/_3$)	1.6X ($^2/_3$)
Medium yellow	8 (K2)	2X (1)	1.6X ($^2/_3$)
Dark yellow	15 (G)	3.2X (1 $^2/_3$)	2X (1)
Yellow green	11 (X1)	4X (2)	3.2X (1 $^2/_3$)
Light green	56 (X0)	6.4X (2 $^2/_3$)	6.4X (2 $^2/_3$)
Medium green	13 (X2)	5X (2 $^1/_3$)	4X (2)
Dark green	58 (B)	8X (3)	8X (3)
Dark green	61 (N)	10X (3 $^1/_3$)	10X (3 $^1/_3$)
Medium orange	16 (G15)	3.2X (1 $^2/_3$)	3.2X (1 $^2/_3$)
Dark orange	21	5X (2 $^1/_3$)	4X (2)
Light red	23A	6.4X (2 $^2/_3$)	3.2X (1 $^2/_3$)
Medium red	25A (A)	8X (3)	6.4X (2 $^2/_3$)
Dark red	29 (F)	16.4 (4 $^1/_3$)	4X (2)
Dark blue	47 (C5)	5X (2 $^1/_3$)	8X (3)

* The designations in the parentheses refer to *f*-stops, or increases in exposure, and should be used as guidelines, not strict rules.

** The numbers in the parentheses refer to the old Kodak designations, which are still used occasionally.

green, and blue—are so intense that if they're used with color film, they'll produce very strong color casts. These chromatic filters are numbered within each color group to indicate their strength (see Figure 4-1). For example, a 23A red filter is lighter than a 25A red filter, which in turn is lighter than a 29A red filter.

CONTROLLING COLOR TRANSLATION

Controlling the appearance of tones in a black-and-white print is usually done to separate subject matter. This increases contrast between tones as it renders a scene in a natural gradation. So it is difficult to label the effect of a particular filter as "corrective" versus "contrast producing." In practice, both mechanisms

I particularly like the subtle changes in the rendering of skin tones when an 11 green filter is combined with a soft-focus filter, such as a Cokin No. 1 diffusion filter. Here a strobe was shot through a light panel.

are commonly at work. It is more appropriate, therefore, to think of the ways tonal separations prevent the merging of similar gray tones and control the brightness range of a scene as the rough equivalents of correction and contrast. For example, by learning how colors translate, you can anticipate an unwanted mixing and correct for it by separating the tones.

The earlier example of shooting a dark red barn and deep green foliage with a green or a red filter illustrates this. Suppose that the scene also contains significant areas of clear, blue sky and puffy, white clouds. These will show up as an overall bright area in an unfiltered print: because of the film's sensitivity to blue, the sky will expose at about the same density as the white clouds. If you use the green filter, the sky will become dark since the green will block some of the blue of the sky. But using a red filter will really darken the sky, almost to black.

Obviously, very often you have to make decisions about corrections and contrast concurrently. Unfortunately, you may not always understand this if your thinking is couched in such oversimplifications as "Colored filters increase contrast" and "Use a yellow filter to bring out the clouds." This kind of circumscribed reasoning can lead to many missed opportunities. It is far more efficient to build up a series of experiences based on a thorough understanding of color theory.

The more desirable approach, therefore, is to apply the specific principles of color filtration to the characteristics of black-and-white materials. Here are some guidelines to keep in mind before you select specific filters. Base your decision about filter use on the need to separate the tones that comprise your centers of interest. In a portrait the key factors are: skin tone and lip color for lighter-skinned individuals (darker-skinned individuals show fewer changes); hair color for people with blond, red, and silver blue hair; and eye color for people with light blue or green eyes. Be aware of the natural red tint in many faces, and watch out for tonal mergers between hair, backgrounds, and clothing when filtering for a person. Yellow and yellow-green filters provide about the best tonal correction for moderate separation in the facial features of light-skinned individuals, but they darken silver-blue hair.

When you shoot landscapes, pay particular attention to the colors that dominate the scene, regardless of their relation to the center of interest. These colors have the potential to become strong, secondary attractions with their own visual center that will compete with the main subject if they're translated too dark or too light.

Since clouds are usually white or gray, they're unaffected by colored filters. So using contrast and shadow to highlight detail is the result of print manipulation through burning and dodging in the darkroom. The one exception occurs when color is present in the clouds, as in this post-sunset shot. Here for a few moments just after sunset, some color was picked up by the clouds. Under such conditions you can use chromatic filters to selectively lighten or darken the colored areas.

Overcast skies present few options for filtration because they leave no blue sky to darken in order to build contrast. The only option is to render them darker with a graduated neutral-density filter, which holds back the light in the overcast areas. Here, I chose a Tiffen 0.9 graduated neutral-density filter to underexpose the sky on the negative.

Unlike the Macbeth ColorChecker, the subjects in these photographs aren't made up of pure colors but rather mixtures. So the effect of filters will vary depending on how much of a certain color is present. For example, using a 25 red filter turns medium red tomatoes almost white while the dark red background appears just slightly lighter. Thus, the effect of color filters to lighten or darken colors depends on the purity of the filter's color in the subject.

No filter

No filter

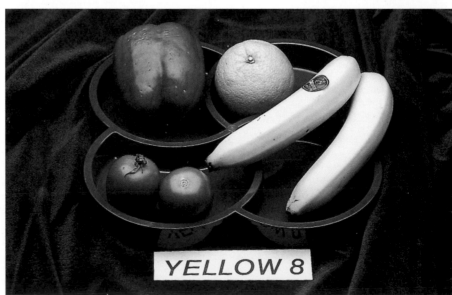

8 Yellow filter

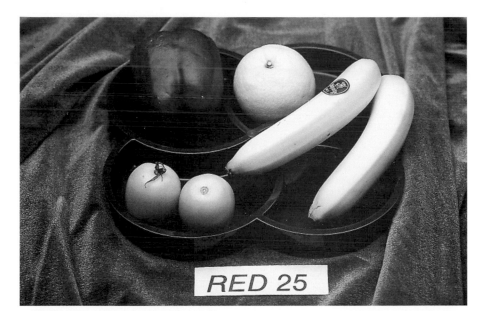

25 Red filter

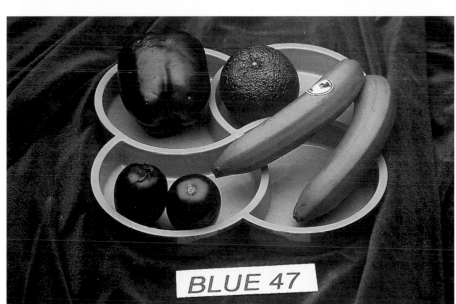

47 Blue filter

These colors are found, for example, in large areas of water, trees, and sky. Select filters with an eye to these parts of a scene.

Skies, with or without clouds, play a major role in most landscapes. Unlike a clear sky with its predominance of blue, a completely clouded-over sky doesn't respond to filtration because all colors are present. By the way if you utilize filters to darken a large, clear area, you are more likely to see film grain. As such a fine-grain emulsion is a better choice in this situation. White skies near the horizon and white areas around the sun respond little if at all to chromatic filtration, which very often produces an unevenly graded shading from light at the bottom to dark at the top.

However, chromatic filters excel in their ability to penetrate haze. The colors remove the excess blue and are able to bypass the UV effect. To penetrate the fog-like effect of UV radiation, use a progressively darker filter for stronger results; for example, proceed from yellow, to green, to orange, to red. Generally the longer the photographic distance and the longer the focal length of the lens, the stronger the filter must be. (Telephoto lenses cover a narrow angle of view but compress subject matter through magnification.) When photographing clouds, avoid overexposure, which builds up density in the negative. This in turn eliminates fine details of tonal separation. You should also use faster shutter speeds—1/125 sec. or faster—on windy days to freeze movement.

Chromatic filters have no effect on white, black, or gray areas, so you'll find that the problems associated with neutrals don't occur with monochrome work.

FIGURE 4-2. CHROMATIC-FILTER RECOMMENDATIONS FOR BLACK-AND-WHITE FILMS

Subject	Desired Effect	Filter Required
Clouds, sky	Natural-looking sky	8 yellow
	Very dark sky	25 red
	Black sky	25 red + polarizer
	Whitening of sky or elimination of clouds	47 blue
	Darkening of pink, red, and orange streaks in clouds to give them texture near sunrise or sunset	3 yellow-green or 58 green
Copy work	Elimination of brown or yellow stains	11 yellow-green
	Increased contrast in faded, yellowed print; blueprints; or elimination of blue lines on graph paper, leaving only graph	47 blue
Haze	Extensive penetration or darkening of foliage	25 red
	Extensive penetration or lightening of foliage	11 yellow-green
	Penetration equivalent to 15 yellow without change in foliage	UV or UV + polarizer
	Medium amount of penetration	16 orange, 21 orange, or 15 yellow
	Exaggerated haze	47 blue
Landscapes	Natural tonal rendering, especially when light-skinned people are in the scene	8 yellow or 11 yellow-green
	Separation of abundant green tones	58 green
	Separation of abundant orange tones between the sky and water in marine scenes, and especially autumn foliage	16 orange
	Darkening of blue in shadows and enhancing texture in snowscapes	11 blue
	Pure white, textureless snow against pale sky	47 blue
	Moderately dark leaves and sky, and almost black fir trees	FLD or CC30TK
Moonlight, night	Natural rendering (shooting during the day)	25 red + polarizer; or 23 red + 58 green (slightly underexpose negative by 1/2 to 1 stop, and print it 20 to 30% darker; avoid glare, the sun, and window reflections, which will reveal that the picture was shot during the day; try to include moon)
Portraits	Natural tonal rendering with light-skinned subjects	11 yellow-green
	Swarthy complexions in natural light or with flash	47 blue
	Swarthy complexions in tungsten light	13 green
	Pasty, toneless complexions and pale lips	25 red (may bring out freckles)
Wood finishes	Lightening of cherry, mahogany, or darker walnut finishes	25 red or 15 yellow
	Darkening of cherry, mahogany, or darker walnut finishes	58 green
	Lightening of lighter finishes	47 blue
	Darkening of lighter finishes	8 yellow, 15 yellow, 11 yellow-green, 25 red

Like white clouds, pure white snow isn't responsive to chromatic filters. If there are shaded portions, however, you can use a yellow or orange filter to darken these areas because of the presence of blue. In the negative this portion is underexposed since these filters block blue light, causing it to appear slightly darker. For this shot, I used an 11 orange filter.

Furthermore, this explains why clouds almost always remain white (or gray on overcast days) in the presence of all chromatic filtration. The only exceptions to this are at or near sunrise and sunset when reds, pinks, yellows, and oranges are reflected off the clouds. At these times chromatic filters further define the clouds' shapes and forms. Snow is also impervious to filtration as long as it is pure white, but you can darken any shadows on snow with a yellow filter because of their blue content. You can often pick up greater detail in sidelit snow by darkening shadows in this manner. And in order to remove much of these shadings on pure white, producing textureless snow, you need to use a blue filter.

Since tungsten light contains more red than daylight or flash, you may have a problem with certain black-and-white films when doing small-product work or portraits. The newer monochrome emulsions don't seem to react as critically to the extra red, so a light yellow filter is usually all you need to correct tones.

When you shoot monochrome film, you find that each scene and subject has its own unique qualities, and that you must consider them individually. Unfortunately photographers often overlook this given when they begin to use filters and receive positive feedback about the results. Always ask yourself this two-part question: What am I taking a picture of, and how will it show up in black and white? Furthermore, be very sensitive to unusual mixed colors, such as those found in wood surfaces and lush, green areas of deciduous and coniferous foliage. The many different colors in this scene may require you to give some very careful thought about translation. (See Figure 4-2 for some specific filter recommendations for the most common subject matter.)

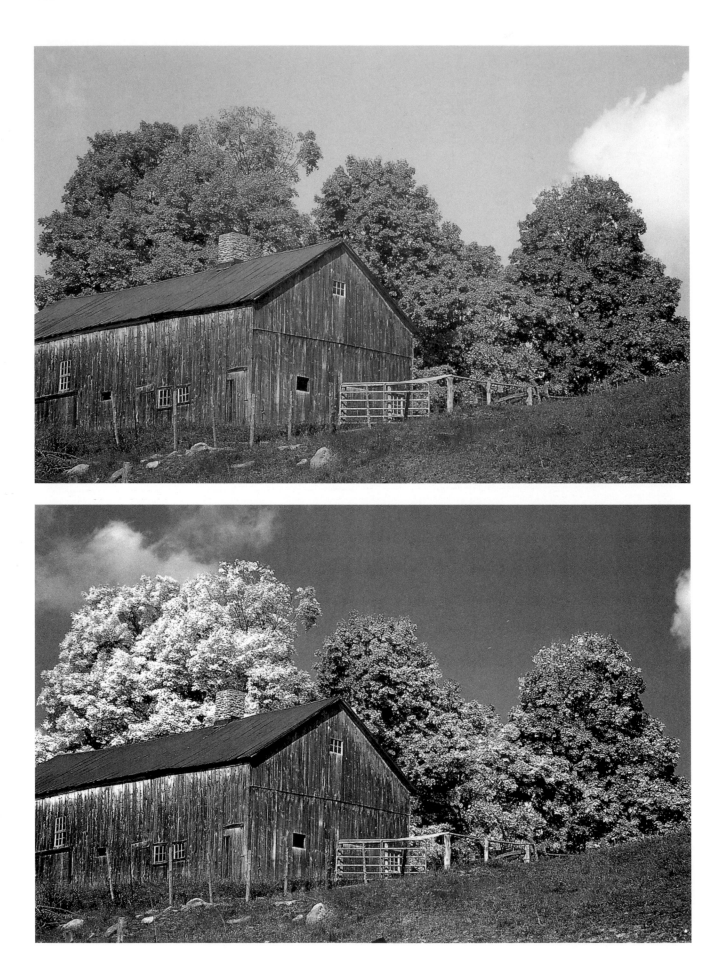

Chromatic filters make it possible to separate out various colors in black-and-white landscapes. After photographing a barn unfiltered (opposite top), I used both a 21 orange filter to separate the orange and yellow fall foliage colors of the trees and a polarizer to add density to the sky (opposite bottom). In another example, a 47 blue filter dramatically darkened the red veins in the white flowers (left) in comparison to the 23 red filter that lightened the red lines enough to make the veins disappear (right).

USING CHROMATIC FILTERS IN THE DARKROOM

You might be wondering if you can use chromatic camera filters in the darkroom to further change the tones in a final black-and-white print. The answer is no, unless you're trying to print a colored negative. Under special conditions it is possible to change the photograph's appearance. To clarify this, keep in mind that when making a black-and-white print, you control the brightness by increasing or decreasing the light from the negative or the time in the developer. The more light from the negative or the more time in the developer, the darker the print; the less light or time in the developer, the lighter the print. Most darkroom workers control brightness by exposure and minor alterations in development time since major changes in development beyond the optimum time often reduce the paper's ability to exhibit a full gray scale.

Photographic papers come in several contrast grades, from high to normal to low. So a normal-contrast negative is printed on a normal-grade paper; a low-contrast negative is printed on a high-contrast paper, which has more contrast built in to make up for what's missing in the negative; and, of course, a high-contrast negative is printed on a low-contrast paper, which has less contrast built in. A second type of paper, whose names usually begin with the prefix "poly" or "multi," are *variable-contrast (VC) papers*. These include Kodak's Poly Contrast, Ilford's Multigrade, and Agfa's Multicontrast papers. You can alter the contrast in these emulsions via the use of special printing filters that range from light yellow for the lower contrasts, to orange and pink for normal contrasts, up to magenta for high contrasts. You'll find that CP filters, which are the darkroom equivalent of camera CC filters, can be substituted for them since both types of filters work on the principle of subtractive color filtration of the enlarger's white light source (see Figure 4-3).

So you can use chromatic filters and VC papers in the darkroom to control overall contrast, which is the

You can alter variable-contrast papers via variable-contrast printing filters or equivalent color-compensating and color-print filters. For these shots I used Kodak's Poly Contrast III paper with poly-contrast filters. The differences between shooting with a #1 filter (left) and a #4 filter (right) are quite apparent.

Copying monochromatic subjects, photographs, or three-dimensional artwork under tungsten light with color film often produces a bluish cast from aging bulbs or ultraviolet reflectance from the subject. I used an 81A warming filter for this shot to offset the effect of aged 3200K bulbs on Type B color-slide film.

FIGURE 4-3. COLOR-COMPENSATING-FILTER RECOMMENDATIONS FOR VARIABLE-CONTRAST BLACK-AND-WHITE PAPERS

Paper Contrast Grade	Color-Compensating Filtration*
1	25 yellow
1 1/2	12 yellow + 9 magenta
2	4 yellow + 9 magenta
2 1/2	7 yellow + 20 magenta
3	10 yellow + 70 magenta
3 1/2	20 yellow + 140 magenta

* Filtration refers to color-print enlarger filters.

result of the richness of whites and blacks and the presence of grays. But these filters don't separate out tones as they do in the camera. The only way you can accomplish this is by printing a color negative onto black-and-white paper; this enables you to take advantage of the different colored layers that can be filtered as the enlarger light passes through them in the usual subtractive method. So if you wish to change the way a particular tone of a color shows up in the print, you'll filter that negative according to the rules of color printing. You'll need CP filters to lighten or darken color transmission from the negative. You'll see these differences, whether or not you use graded or VC paper. But if VC filters are already in use, further manipulation with CP filtration to gain tonal control will be minimal.

You'll achieve the best results when you use CP filters with a color negative on special graded black-and-white paper that is intended for colored negatives, such as Kodak's Ektalure. This is an interesting darkroom combination that becomes more functional as the quality of color-print films continues to improve. Some darkroom workers claim that this approach yields better results than copying a color print first on black-and-white negative film and then printing it in the conventional manner. (I still prefer the latter approach.)

In addition to toning and using various paper surfaces, you can also introduce color into black-and-white images by converting a print to a monochrome slide and then sandwiching a colored gel across the whole slide or splitting two gels over the field. You can also photograph the print with colored film, and then use a gel over the light source or a filter on the camera.

USING NONCHROMATIC FILTERS WITH COLOR AND BLACK-AND-WHITE FILM

Nonchromatic filters change the physical composition of light. In a few situations, this ability in turn results in a comparable alteration of light's chromatic characteristics. In other words, this group of filters doesn't rely on color to change the content of white light; instead they alter the light waves themselves. Most of these filters are in fact colorless or look gray, hence their name.

The easiest way to classify nonchromatic filters is according to their function. (Many also have secondary uses, thereby continuing the "variations on a theme" analogy.) In terms of prime function, the groupings are:

FILTER	PRIME FUNCTION
Neutral-Density	Blocks light to control exposure
Closeup	Decreases minimum focusing distance
Haze/Fog	Increases or decreases haze/fog effects
Polarizing	Increases or decreases glare, affecting saturation
Diffusion/Soft-Focus	Decreases sharpness or small detail

NEUTRAL-DENSITY FILTERS

The sole purpose of *neutral-density (ND) filters* is to reduce the amount of light reaching the film without changing any other attribute of light. This is achieved via the application of various densities of a neutral-gray, light-blocking substance over the filter in one of four configurations: 1) evenly, over the entire filter; over just half of the total area, ending in either 2) a graduated pattern, where the area between the clear and the neutral-gray parts of the filter is feathered for the *soft-edge design,* or 3) a *split-field design,* where the area between the two different portions of the filter is well defined by a sharp line; and 4) the *center-spot design,* in which the neutral-density material is distributed throughout the middle third of the lens and radiates from the center to the edges in a gradual delineation.

When do you use ND filters? The most common situation is when you're using a film that is much too

FIGURE 5-1. FILTER RECOMMENDATIONS FOR REDUCING LIGHT TRANSMISSION

Neutral Density*	Percent Transmission	Filter Factor	Light Loss in Stops
0.1	80	1 $\frac{1}{4}$	$\frac{1}{3}$
0.2	63	1 $\frac{1}{2}$	$\frac{2}{3}$
0.3	50	2	1
0.4	40	2 $\frac{1}{2}$	1 $\frac{1}{3}$
0.5	32	3	1 $\frac{2}{3}$
0.6	25	4	2
0.7	20	5	2 $\frac{1}{3}$
0.8	16	6	2 $\frac{2}{3}$
0.9	13	8	3
1.0	10	10	3 $\frac{1}{3}$
2.0	1	100	6 $\frac{2}{3}$
3.0	0.1	1.000	10
4.0	0.01	10.000	13 $\frac{1}{3}$

* These figures refer to Kodak neutral-density filters but can be used for other manufacturers' filters, too.

fast for bright light conditions. The evenly dispersed ND designs can reduce overall exposure anywhere from half a stop to three or more stops. Suppose you're shooting an ultra-high-speed film with an ISO rating of 1600 or 3200 to record a wedding ceremony indoors under limited lighting. Later the festivities move outside, and you can't set your camera's aperture to a small enough opening and the shutter speed fast enough to reduce light transmission to proper exposure levels. So you must use an ND filter to decrease the light transmission.

Another very good reason to use ND filters is to enable you to set wide-open apertures in order to reduce *depth of field*. This is the area in front of and behind the *point of focus* where the subject matter appears sharp. When you place a background outside the lens' depth of field, you isolate the subject because the background falls out of focus. This is very desirable in certain conditions, but is unobtainable when you're shooting a fast film, ISO 400 or 1000, or even a moderate-speed film, ISO 100 or 200, in bright light (see Figures 5-1 and 5-2).

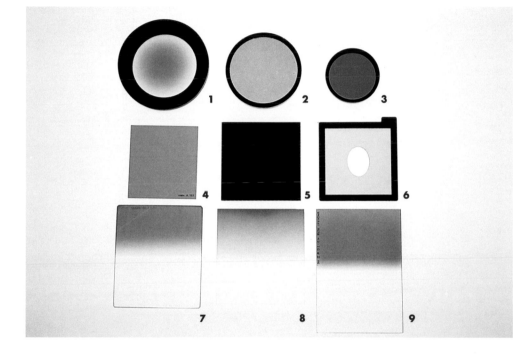

Neutral-density filters are designed to cut down on exposure. They come in different configurations, and the coloration between densities and brands may vary. The density material usually covers the entire surface of the filter, as you can see in (2) the Tiffen 0.6, (3) the B&W 8X, (4) the Cokin 4X, and (5) the Kodak Gel 2.0 filters. There are also different types of graduated styles, such as (7) the Tiffen 0.6, (8) the Cromatek 0.6, and (9) the Singh-Ray ND2-2G filters. Other designs include (1) the Heliopan Center Spot ND 0.45 and (6) the Cromatek Soft Focus Cameo filters.

FIGURE 5-2. CONTROLLING DEPTH OF FIELD WITH NEUTRAL-DENSITY FILTERS

Original Aperture	Desired Aperture				
	$f/5.6$	$f/4$	$f/2.8$	$f/2$	$f/1.4$
	Neutral-Density Filter Required				
$f/8$	0.30	0.60	0.90	0.90 + 0.30	0.90 + 0.60
$f/11$	0.60	0.90	0.90 + 0.30	0.90 + 0.60	0.90 + 0.90
$f/16$	0.90	0.90 + 0.30	0.90 + 0.60	0.90 + 0.90	2.00 + 0.10
$f/22$	0.90 + 0.30	0.90 + 0.60	0.90 +0.90	2.00 + 0.10	—

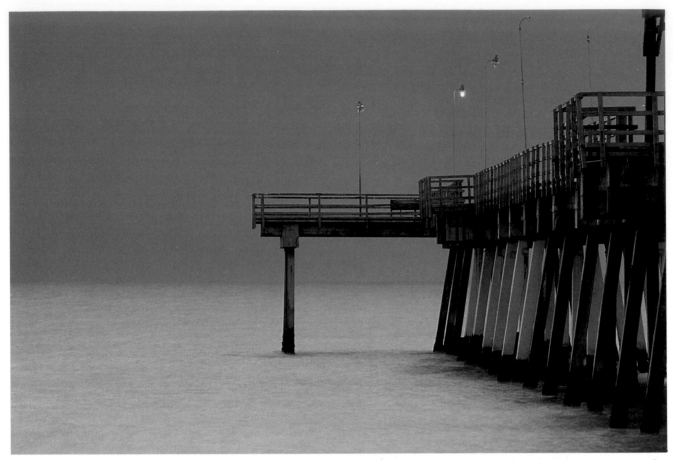

Neutral-density filters can also be used to photograph moving subjects at very slow shutter speeds with the camera mounted on a tripod. So you can flatten out waves to make the ocean look calm with a 2-minute exposure, as shown here. This filter/shutter-speed combination also enables you to give water a mist-like quality.

To make this scene appear abstract, I used an 8-minute exposure along with a CC40 red filter.

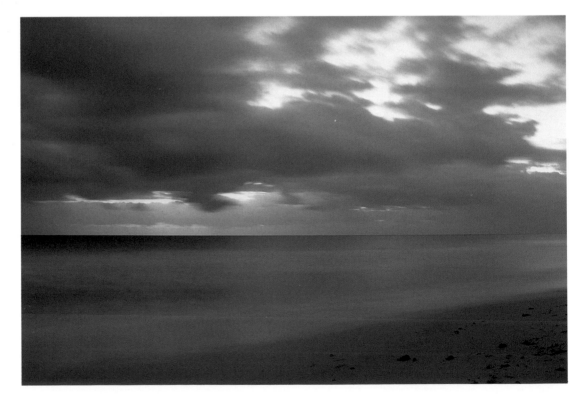

Neutral-density filters allow the use of slower shutter speeds in bright sun to produce various effects. To capture this rodeo scene, I panned the subject with a shutter speed of 1/30 sec. while using a 0.6 neutral-density filter.

You can also use ND filters to reduce shutter ratings in order to obtain various slow-shutter-speed effects. Decreasing shutter speeds to blur the motion of a moving subject, such as a waterfall, a car, or a runner, is difficult when you shoot fast or even moderately fast films because speeds of 1/2 sec. to several seconds are often required. Again ND filters lessen the amount of light transmission by several stops, thereby allowing you to set much slower shutter speeds.

Another application that has become easier to carry out in the last few years is the selective light reduction of up to half of a picture area in order to reduce brightness differences that are beyond the recording latitude of the film when you shoot outdoors. This excessive brightness range is commonly a problem with landscapes containing large segments of highly

reflective surfaces, such as big areas of sky or water. Because these sections very often fall at the top or bottom of a composition, you can decrease their brightness by using a graduated or split-field ND filter. Although these filters enable you to alter brightness levels by several stops, many times all that is necessary is a 1-stop or 1 1/2-stop reduction. These filters come in two forms. The circular glass style limits you to a correction of 50 percent of the picture area, while the more flexible, rectangular-bracket style can be moved up and down for variations in coverage. Other uses include reducing the amount of light reflecting off wet roadways in sunlight, lowering the extreme contrast of sunsets, and increasing the density of white, puffy clouds behind which is streaking sunshine.

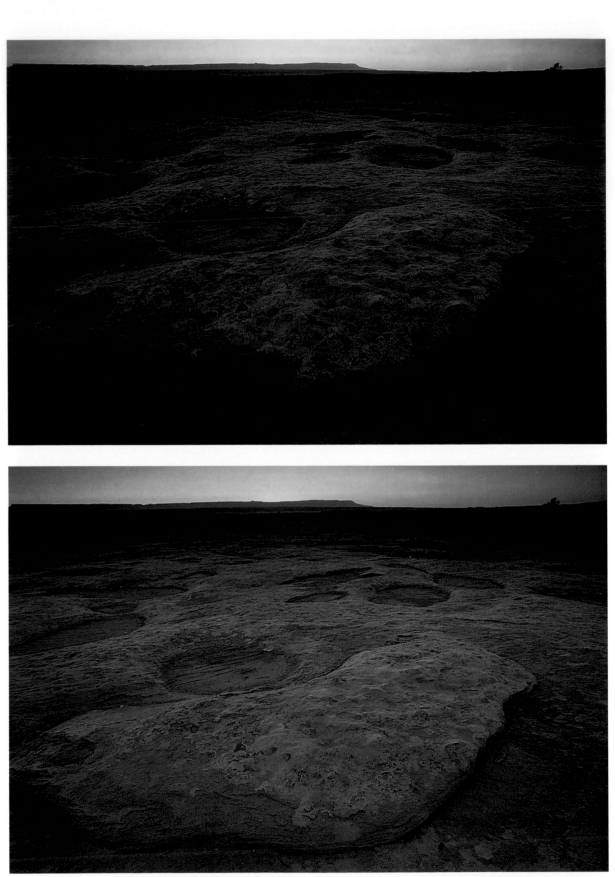

Graduated neutral-density filters effectively reduce lighting contrast; they lower the intensity of the lower half of a scene, as in the case of reflections off a lake or a bright sky. Here I used a 0.90 ND graduated filter and a CC10 magenta filter (bottom) in order to prevent the underexposure of the foreground as seen in the unfiltered shot (top).

I actually like what edge-light falloff does to images and how it isolates a subject. To achieve this effect, I had a filter company make up a filter with neutral-density material sprayed unevenly around the edges of a circular filter.

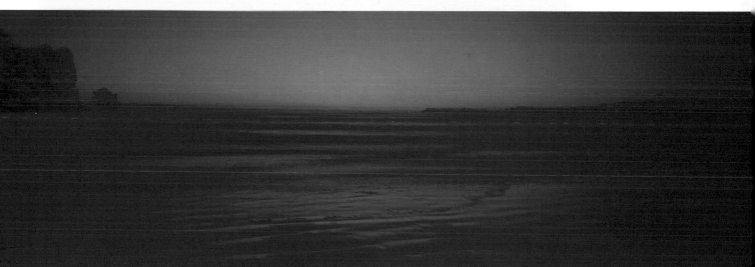

Ultrawide-angle lenses in large-format and panoramic cameras often display light falloff at the edges, as in this shot made with a 6 x 17cm fixed-lens panoramic camera. The solution is to use a center-spot filter, which reduces the light transmission of the middle third of the lens and balances the exposure.

Center-spot ND filters are reserved for ultrawide-angle lenses that produce noticeable light falloff at the edges. Differences of one stop in light transmission between the center and the edges are fairly common among large-format and panoramic lenses, whose horizontal field of coverage is between 70 and 100 degrees. The blocking material holds back enough center-transmitted light to even out exposure. While some ultrawide-angle 35mm and medium-format lenses show falloff, it usually isn't enough to warrant the use of these filters.

CLOSEUP FILTERS

Most photographic lenses are designed to record subject matter between moderate distances and infinity. By mounting a *closeup filter,* often called a *closeup auxiliary lens* or *diopter,* on the front of a

camera lens, you can focus nearer to a subject without any loss of light transmission; this problem occurs with other supplementary devices, such as extension tubes, rings, and bellows. Closeup filters are the most inexpensive way to change the minimum focusing distance. They come in various *diopter ranges,* or strengths, which range from a weak +1 to a very strong +10; sets containing +1, +2, and +3 filters are the most common. Closeup filters can be used singularly or in pairs. For example, you can combine a +1 filter and +2 filter to equal a +3 filter when a +3 filter isn't available (see Figure 5-3).

How much quality can you expect from such an inexpensive approach to shooting closeups when macro lenses, which are designed specifically for this type of work, are about twice the price

Closeup filters reduce the minimum focusing distance of a lens when they're mounted over the front element. They come in various diopter strengths, from +1 to +10, and in two configurations. The most common single filter fits over the whole lens and comes in either a circular, square, or rectangular form. A split-field filter (mounted on the camera) affects only half of the scene and allows for closeups of near objects.

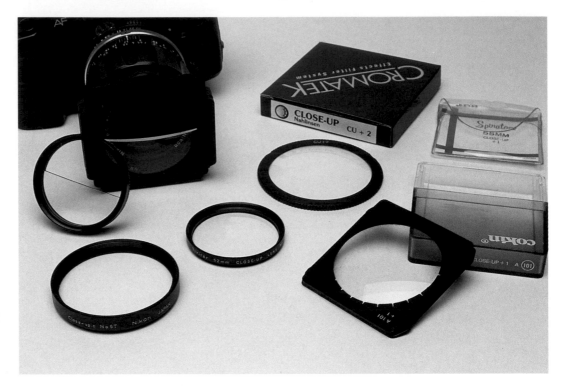

FIGURE 5-3. THE EFFECT OF CLOSEUP FILTERS ON CLOSE-FOCUSING DISTANCES

Diopter Rating	Distance Between Subject and Closeup Lens (in inches)*	Area Seen	
		50mm lens, 24 x 36mm negative	75mm lens, 6 x 6cm negative
+1	$20^3/_8$	$9^1/_4 \times 14$	$14^3/_8 \times 14^3/_8$
+2	$13^3/_8$	$6^1/_8 \times 9^3/_4$	$8^7/_8 \times 8^7/_8$
+3	10	$4^1/_2 \times 6^7/_8$	7×7
+4 (+3 + +1)	8	$3^5/_8 \times 5^3/_8$	$5^1/_2 \times 5^1/_2$
+5 (+3 + +2)	$6^1/_2$	$3 \times 4^3/_8$	$4^1/_2 \times 4^1/_2$
+6 (+3 + +3)	$5^5/_8$	$2^1/_2 \times 3^3/_4$	$3^7/_8 \times 3^7/_8$

* With no filter, the lens is focused at a maximum close distance of $3^1/_2$ feet.
 Courtesy of Tiffen Filters, Inc.

Adding a high-quality, multiple-element closeup lens, such as a Nikon 5T lens, to the front of a high-quality macro lens usually gives excellent results while enabling you to get more than the 1:1 magnification typical of a true macro lens.

Closeup filters enable you to decrease your lens' minimum focusing distance as shown here. First I focused a 50mm standard lens (top) and then used four closeup lenses: a +1 lens (center), a +2 lens (bottom), a +3 lens (opposite page, top), and a +4 lens (opposite page, bottom).

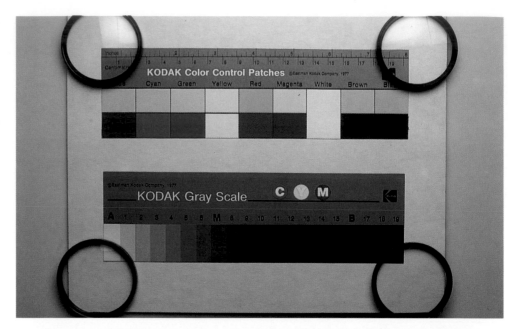

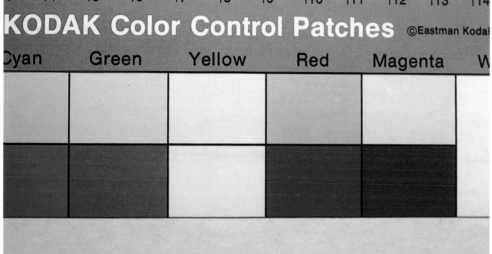

of comparable nonmacro lenses? Under certain conditions the results can be quite good, but once you stretch beyond these, sharpness drops off. In 35mm photography these filters work best with standard lenses or short telephoto lenses of about 100mm and in low strengths of +1 on flat subjects. You should stop down from the maximum aperture by two or three stops, which is customarily the sharpest aperture (assuming that you have a high-quality lens). Most of these filters are made of a *single lens element*. A few, such as a type made by Nikon, are *double-element lenses;* their quality is significantly better under ideal conditions. This is because the second element enables optical engineers to better

correct for sharpness. In more challenging situations, such as when you photograph three-dimensional objects or use a high diopter power of +2 or more, you'll experience loss of sharpness, especially at the edges of your images.

A second, less commonly used closeup filter is the split-field type in which the glass covers only one half of the field. This design enables you to focus on a close object, such as a flower in the foreground, while still holding distant objects, such as buildings, in sharp focus. This effectively increases the depth of field of a lens when you can arrange a shot so that the line of focus between the empty and glass portions of the filter is hidden by diffused subject matter in the scene.

The quality of double-element filters is noticeably better than that of single-element designs. I chose a Nikon 5T double-element filter and a 200mm lens to achieve this extreme closeup of a sunflower.

Split-field closeup filters enable you to get very close to a foreground subject and still keep distant objects in focus. Here, a +1 split-field filter allowed me to get about 8 inches from the filters while keeping the buildings in focus, something my camera lens was unable to do. The trick is to hide the demarcation line produced by the filter's edge, as I did here in the sidewalk just below the grass.

HAZE AND FOG FILTERS

I've grouped these two very different—in fact, opposite-effect—filters together because they're both intended for atmospheric effects. *Haze filters* penetrate the UV-abundant atmosphere, while *fog filters* introduce fog where none is present or increase its effect. Haze is a general term that refers to a combination of water droplets, dust, and, increasingly, pollution, which unfortunately is more and more becoming the predominant component. This mixture lays on the horizon in a band of gradation that sometimes extends upward into the higher levels of the sky. When the light rays hit this assortment of particles, two visual effects are produced: a separation of some of the color wavelengths and a scattering of the rays. In color photography the effect of distant haze is a noticeable blueing, while in black-and-white photography a general loss of contrast and a "graying-down" of the distant tonal scale. The major causes of both effects are the scattering of the wavelengths, especially at the blue end, and the UV radiation's impact on the film.

Fog and mist create a different problem. Unlike the much smaller particles of haze, mist and fog are made up of larger droplets of water. The water causes two things to happen: light passes through the mist or fog, thereby allowing the red end of the spectrum to pass, scattering blue. Also, light hitting from the camera position reflects back the blue and passes the red through. The result is a white, translucent cloud with a bluish cast.

Fog scatters light rays, mutes colors, and causes a loss of contrast, as you can see in this forest scene. The farther away from the camera, the less distinct the subject matter appears until it disappears entirely. (Courtesy of John Denver)

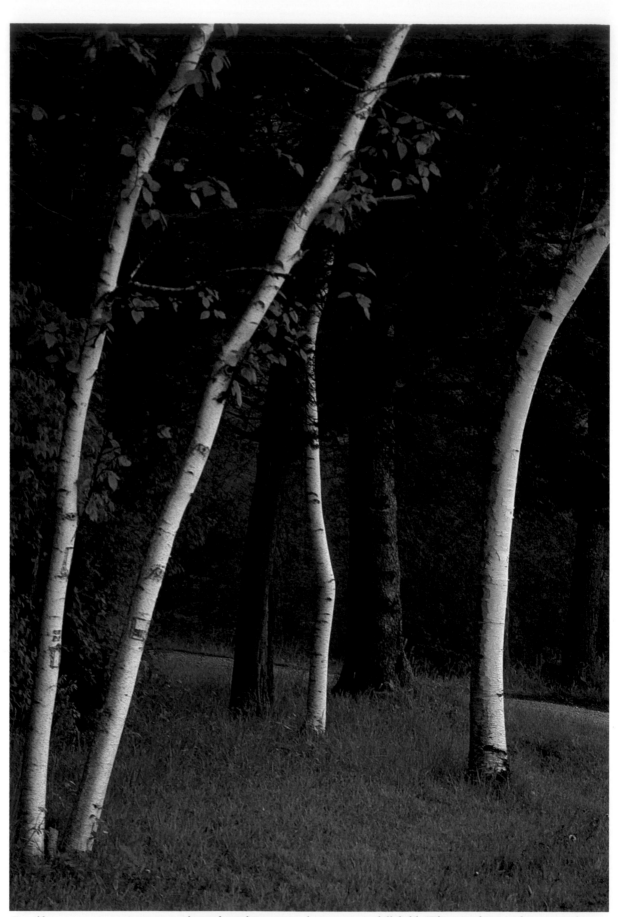

Fog filters come in various strengths and configurations, but most are full field. When used in weaker strengths, such as the Hoya Fog 1 filter used to make this shot, the results can be subtle.

Fog filters can be used to intensify existing fog. I used the Cokin Fog #2 filter for this picture of a man in a boat at the water's edge (left). You can also add color to a scene, as I did by combining an 85C conversion filter and a Spiratone Mistmaker (right). Here, I shot ISO 1000 daylight film.

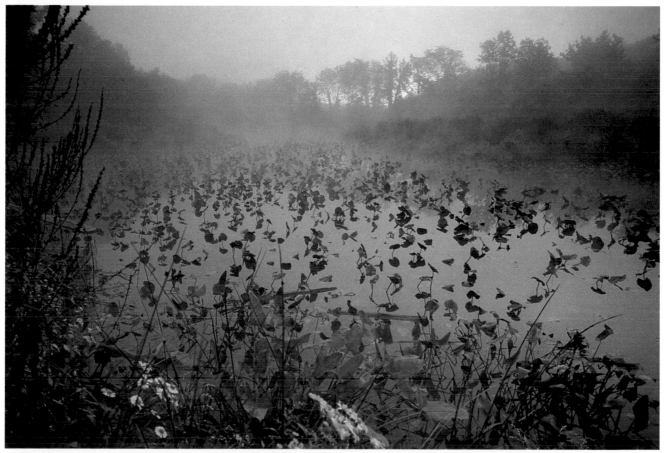

Several fog filters come in graduated form to simulate ground fog. Harrison and Harrison's unique Misty Morning filter contains a thin "fog strip" across the upper third of its surface that allows you to give the impression of aerial fog lifting, as in this pond shot.

To deal with the diverse conditions of haze and fog or mist, you must remember that although you see only white light, both black-and-white and color films are also sensitive to UV light (which you don't see). If you're working with monochrome film, you can eliminate much of the blue and UV effects via such filters as yellow and, especially, red ones (see page 109). These filters are the best choices for monochrome emulsions.

With color film, you must remove the UV light; otherwise chromatic filtration would produce unacceptable color casts. You can achieve this by using either a clear UV filter or a slightly pinkish skylight filter. Both can be quite effective, but keep in mind that the skylight filter adds a somewhat warmer look to transparency film because of its pink cast. With color-negative film the pink effect is often removed via corrective filtration during the printing process.

Haze, ultraviolet, and skylight filters are primarily intended to reduce the amount of ultraviolet light reaching the film. As shown here, skylight filters, such as the Hoya 1B (left), have a slightly pinkish look while "regular" strength ultraviolet designs, like that of the Tiffen Haze 1, are clear (bottom center). Stronger ultraviolet formulas are more effective, but also have slight color casts. These include the Tiffen Haze 2A filter (top center) and the Sailwind Ultra V filter (right).

The ability of ultraviolet and skylight filters to penetrate haze depends on the content of what is perceived as haze. In this shot, made with the equivalent of an 800mm lens, a Tiffen Haze 1A filter successfully penetrated the light haze that was visible from the camera position. There is just the slightest hint of blue, indicating that a skylight filter might have been an acceptable alternative.

Polarizers are widely known for their ability to reduce the effects of glare as shown in this before (top) and after (bottom) example of glare reduction. Removing the glare enabled me to record the color of the van with full saturation.

UV filters come in various strengths. For example, Kodak's 2A filter eliminates all ultraviolet radiation, but, unfortunately for slide shooters, it is pale yellow and gives that cast to transparencies. However color-negative shooters can use this filter since the yellow cast can be removed via CP filters. The yellow cast doesn't record on monochrome emulsions. The Kodak 2A is also able to take away a small portion of the blue, so it is a good choice for color-print users and for shooting black-and-white film when you don't want to change any tones in the print with colored filters.

For slide users it comes down to either clear or skylight filters to deal with only the UV portion of the white-blue haze. This leaves only one other choice to consider: the most useful of the nonchromatic filters, the polarizing filter.

POLARIZING FILTERS

You can think of a polarizer as an adjustable screen that, depending on how it's rotated, does or doesn't allow light through it. Essentially, a polarizing filter is a type of ND filter since it blocks light without producing any color shift. So in a pinch you can use a polarizer as a 2.5X-4X ND filter or so, which means about a two-stop loss of light. But polarizers also darken skies in black-and-white images and render them much bluer in color shots, while maximizing the saturation of all colors. How does this happen?

Polarizers filter the physical shape of light, not its color. So they actually deal with light scatter, which is the basis of blue in the skies shot with color film and the light gray in the skies shot in black and white. This scattering causes the "clouding" effect of haze and the light reflected off certain shiny objects. In all of these shooting situations the major culprit is the light that bounces off either suspended particles in the air or off shiny surfaces. This produces a variety of effects, such as an excess of blue or something loosely called *glare* (see page 111).

When light strikes a surface, it can react several ways. It can go through it, as in the case of a transparent lens element; can be absorbed by the subject, as with a black wool sweater; or it can reflect, or bounce, off the surface of the subject, such as a mirror. Obviously, some materials have more than one of these properties. A translucent shower curtain with black polka dots, for example, transmits some light, so that you can see while in the shower; reflects some, thereby giving a translucent look to the curtain so no one can see you in the shower; and absorbs the light (via the black dots), so everyone can see them.

When light does reflect, it does so in three ways that are theoretically different but often occur simultaneously. Reflected light can, for example, take the form of *diffusion*, a *mirror image*, or glare. If the light hits an object, such as a white wool sweater, and the *reflectance* is even over its entire surface, the light will appear in the final image as a diffused reflection. It doesn't matter, by the way, whether the light source is hard (from a small light), medium, or soft (from a large one). The dispersion is so uniform because of

Because a single polarizer allows only light vibrating in one direction to pass, you can demonstrate the filter's ability to block light by using two polarizers, set at different rotations, to block more of the light (right) or all of the light (left).

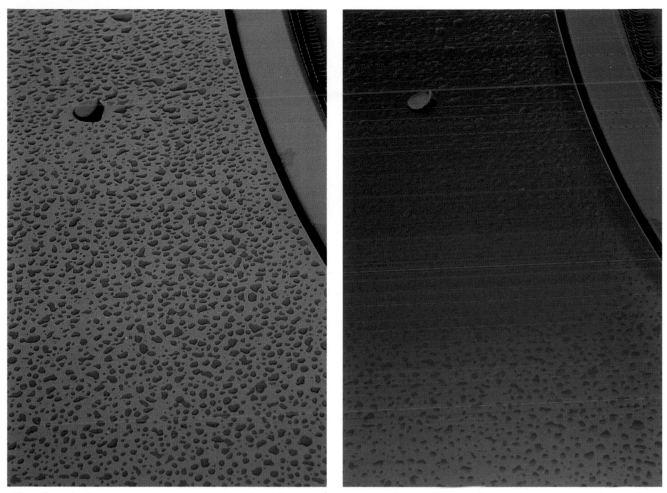

Glare doesn't always appear as a hotspot, but it might spread to entire surfaces, thereby reducing the saturation of any color reflected off that surface. This effect is visible in this shot of an automobile hood on a sunny day (left). When I used a polarizer to remove the glare, full color saturation resulted (right).

the nature of the subject's surface that someone might say that the picture contains no reflections. Of course, this isn't true because you wouldn't be able to see the subject if light didn't reflect off it.

Mirror reflections are exactly what their name implies. The surface is so reflective that no significant diffusion of the rays occurs to scatter them in all directions. Instead, most of the light reaches the surface and then bounces off at the same angle. The light, therefore, remains concentrated and doesn't dissipate. This type of reflection, also called *direct reflection,* causes very little loss of light.

To see a mirror reflection of a light source, you have to be within its *angle of reflection.* This is why you can avoid light shining into your eyes from a chrome bumper by simply moving your head slightly. But no matter where you stand in front of a long, flat, white wall in bright sun, you can't escape the reflected brightness. Many photographers think of mirror reflections as light sources since they are so intense and directional.

Glare is a variant of a mirror reflection with one important difference. Here, the light becomes polarized as a result of the reflection and, therefore, isn't as intense as the light source itself. Otherwise, it is basically the same as a mirror reflection. For example, if you move out of the glare's angle of reflectance, you can't see it. So why does polarizing reduce the amount of light in the reflection? In fact, what is meant by "polarizing"?

Remember, light rays contain wavelengths of color. Physically, light moves through space in waves. But these don't move as straight, long rays or beams; light waves undulate like snakes as they make their way across a flat surface. Picture, if you will, a snake underwater that can undulate on any plane as it moves deeper in a straight-line direction.

When light rays hit a surface, they undulate or, more precisely, vibrate in all directions. In a diffused or mirror reflection, these vibrations remain basically intact. This isn't true of glare: on certain surfaces, such

as glass, water, wet leaves, smooth wood, or plastic (but not metal), the light that reflects loses many of its directional vibrations. The vibrations that survive are oriented in one general polar, vertical direction. The angle of the light source to the reflective surface controls how much of this loss of vibration occurs. Angles between 30 and 35 degrees cause the most polarization (see Figure 5-4).

Now the light is where you want it. As these vertically vibrating rays come toward you, they are very bright and, therefore, obscure the diffused rays coming off the surface they're hitting. If this glare's reflecting off shiny wood or a glass picture frame, you won't be able to see the diffused light of the grain or the picture behind the glass. What you'll be able to see is the shine of the vertically polarized, bright light. What would happen, however, if you had a filter with a special screening material that you could set to block only those vertically polarized, vibrating waves of glaring light, thereby letting the diffused light from the subject, which has waves undulating in all other directions, through? You'd be able to see the reflected, diffused light of the shiny wood and the picture in the glass frame without interference of the polarized glare.

That is precisely what polarizers do. These filters are made up of a series of crystals that are lined up to block the polarized light as well as any of the subject's diffused light whose vibrations happen to be in the same plane as the glare. This accounts for only a small amount of the total diffused light, but at 35 degrees virtually all of the glare light. Because some light isn't transmitted, polarizers typically have filter factors of about 2.5X to correct for the loss. This is identical to the concept of subtractive filtration, when you employ chromatic filters to change the proportions of color in light. But this mechanism is different, and the object is to stop glare, not a particular wavelength of color.

This explains why polarizers are able to make all colors appear more saturated. These filters remove the glare from shiny leaves and from the surfaces of, for example, polished wood furniture and glossy paintings. As a result the diffused light of the subject isn't overpowered. This also reveals why these filters are capable of removing light reflections that typically appear on large glass areas. For example, they can eliminate or drastically minimize the light reflections of nearby buildings on a car's windshield just as they remove light-source glare reflections.

FIGURE 5-4. LIGHT ANGLES AND MAXIMUM POLARIZATION

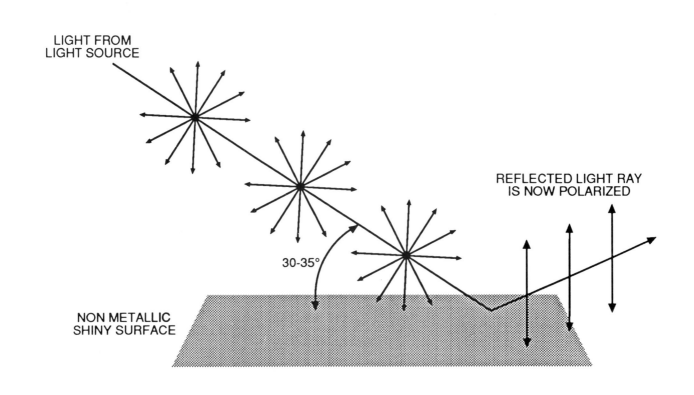

LIGHT FROM
LIGHT SOURCE

REFLECTED LIGHT RAY
IS NOW POLARIZED

30-35°

NON METALLIC
SHINY SURFACE

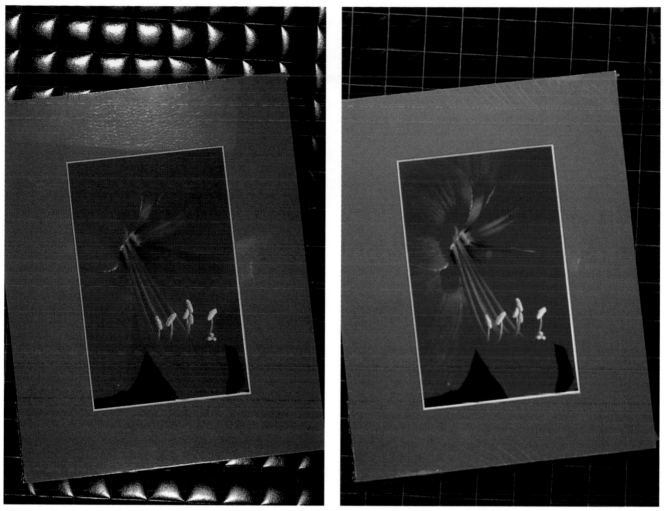

Cross polarization refers to an arrangement in which both the light source and the camera lens are equipped with polarizers. This effectively increases your ability to eliminate glare. The shrink-wrapped photograph set on a shiny raised texture background still shows some glare from the lights of a copystand even though I used a polarizer on the lens (left). To remove the glare, I added polarizing filters to the light sources (right).

The darkening of clear skies in both black-and-white and color photography and the moderate penetration of haze are also due to this type of filter's effect on the presence of polarized light. For skies the amount of change is highly dependent on the location of the light source in relation to the photographer's position, just as in the case of glare reflecting off a shiny surface. If you look at the sky through a polarizer at various angles to the sun, you'll quickly see results, from very dramatic changes to none at all. This is because the area of greatest effect is set at a 90-degree angle to the sun.

The common literal rule of thumb to determine this area is to point your forefinger at the sun while holding your thumb at a 90-degree angle in the shape of a pistol. Then while keeping your forefinger pointed at the sun, rotate your wrist and thumb from one horizon to the other. This half circle across the sky represents the band of greatest change, which

decreases to nothing as you move toward the sun (see Figure 5-5). For this reason it is possible to have pictures in which only a portion of the sky is darkened, to blue or gray. This effect usually isn't visible within the moderate to narrow angles of view of standard or telephoto lenses. But it is very likely to happen with wide-angle and with ultrawide-angle lenses in particular. Most of the time this is disturbing, but there are situations when it can work to your advantage. For example, you can add a glow to the nonpolarized portion of the sky in a photograph.

There may also be occasions when you want to increase the glare reflection to achieve a dramatic purpose, or to transform a rather insignificant level of glare into a more prominent element of the composition. Strangely enough you need a polarizer to do this. As discussed earlier, a polarizer removes some of the nonpolarized light whose vibrations happen to fall

FIGURE 5-5. USING A POLARIZING FILTER IN SUNLIGHT

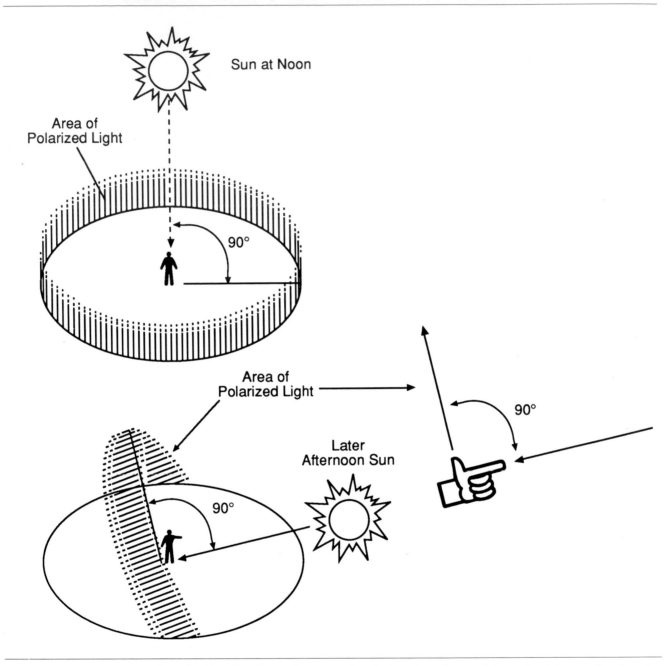

Sun at Noon

Area of Polarized Light

90°

Area of Polarized Light

Later Afternoon Sun

90°

90°

A simple way to determine where the blue-sky effect will occur with polarizers is to form a right angle with your thumb and forefinger as shown here. Point your forefinger at the sun and then rotate your thumb across the sky to trace the arch of maximum effect. Sky areas near the sun won't be affected by the polarizer and will remain white in appearance.

into its alignment, which reduces glare. Suppose, however, that you change the rotation to enable all the glare to come through but cut back some of the nonpolarized diffused light of the subject. Now you have proportionally even more glare to the nonpolarized light in the final image. Once again, the principles of subtractive filtration and proportional transmission are at work.

Beware that in many if not most shooting situations, you face a mixture of glare, diffusion, and perhaps even some mirror reflections. The proportions of each together with the camera angle determine how complete the polarizing will be. So don't expect to magically remove (or increase) glare, darken skies, or increase color saturation. Remember, too, that some surfaces shine but don't give off polarized light, such as

One of the problems associated with polarizers, especially when used with wide-angle lenses, is that the effect on the sky may be uneven because the large angle of view takes in polarized and nonpolarized areas. Also, there is the danger of "overpolarizing," which results in very deep blue skies. You can transform these problems into creative ends by using the weak areas of the sky and the sun's light to produce high-contrast, almost graphic compositions.

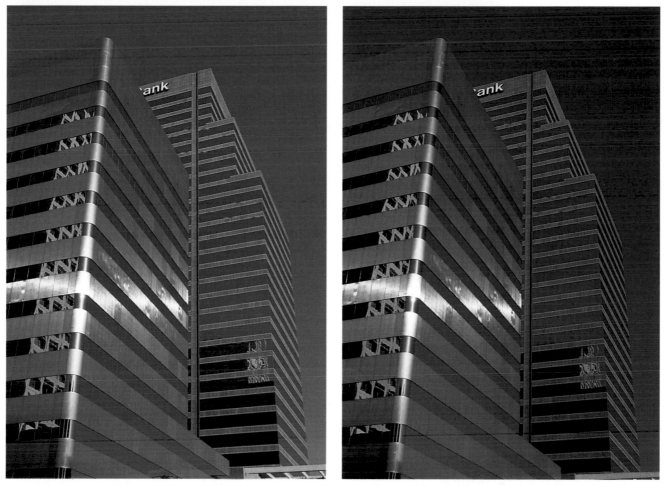

Polarizers have no effect on reflections from shiny, unpainted metal surfaces and won't eliminate mirror reflections unless you are at the proper angle to the subject. So the types of reflections visible in one shot of this office building (left) weren't removed in the second shot, when I used a polarizer (right). But the position of the sun enabled the filter to darken the blue color of the sky.

Producing a diffused or soft-focus effect can be as easy as breathing on a lens, which I did for the shot of the lifeguard station (above) or smearing a very thin, even layer of skin oil over an old UV filter, which I did for a portrait (opposite). The problem with both approaches is that they aren't controlled methods; each application of breath or oil gives slightly different effects.

unpainted, shiny metal. Some photographers say that if a subject conducts electricity and is shiny, you can't use a polarizer on it. This is a pretty accurate generalization. But the only true test is to use a polarizer on the subject and see for yourself. In the case of metallic materials, you can employ a type of double polarization in which you place filters over both the light source and the camera, and then make adjustments in order to completely block glare.

CIRCULAR VERSUS LINEAR POLARIZERS

Polarizers are available in two forms, circular or linear. Linear polarizing filters aren't ordinarily recommended for use with modern cameras with autofocus and multi-

mode metering technology because they might interfere with the accurate operation of these electronically mediated features. For such cameras, the circular form is the better choice. But, generally speaking, you can use either the circular or the linear form with manual-focus cameras.

DIFFUSION AND SOFT-FOCUS FILTERS

Another form of nonchromatic filtration, which is very popular, involves the use of a filter to soften images, especially portraits. The effects range from just removing some details and maintaining overall sharpness and contrast, up to a general diffusion in which contrast and sharpness are greatly affected. There is no precise definition that separates the labels

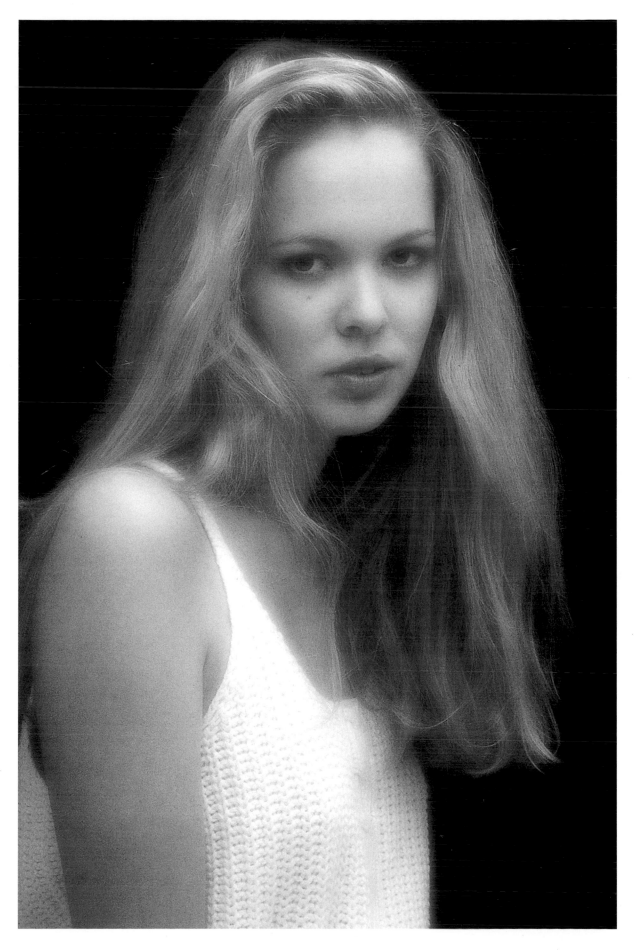

"soft focus" and "diffusion." They're actually used interchangeably, but I tend to think of soft-focus filters in terms of affecting sharpness and diffusion filters' effect on contrast. There are literally hundreds of these filters, as well as other related categories, such as fog and mist filters, and a whole class of lenses called *soft-focus lenses*. To sort them out, remember how a sharp image is formed and go from there.

When light rays pass through a lens, either a single-element lens or a modern multi-element lens, the lens' ultimate function is to bring those rays to fall on the *film plane.* By adjusting the lens' distance to the film, you get a sharp, focused image. If you don't get this distance right by under- or overfocusing, the light rays will fall outside this film plane. The image, then, will be "defocused" and will appear anywhere from slightly soft to completely blurred.

Across this range of effects you lose the finest details first, such as texture, and then larger elements, such as form. Finally, with extreme defocusing, the overall shape of the object is so blurred that you can no longer recognize it. This has implications not only

Diffusion/soft-focus filter effects can range from the subtle softening of an image in indirect sunlight, as shown in the picture of chairs that was made with a Hoya Softener A filter (top), to the exaggerated flare or halo on very bright highlight areas, as shown in the shot of an old room that was made with a Tiffen Pro Mist 3 filter (bottom). So to use these filters successfully, you need to be familiar with the specifics of a filter's effect on a particular type of light.

Portraits are a popular area for special filtration techniques and special-effects filters. For the photograph of the young woman against the blue background, I used daylight film, an 80B conversion filter, and a Harrison and Harrison #5 diffusion filter. Usually having a blue cast with a light-skinned subject doesn't work well but here the diffusion helped provide a softer, more acceptable effect.

Diffusion filters are most frequently used in portrait work, but they're also employed to subtly change the contrast in other subjects, such as this shiny, metallic motorcycle.

for sharpness, but also for contrast, which is, at least in part, dependent on the separation of colors and tones of gray. The more undefined these separations are due to loss of sharpness, the more blending that occurs. This, in turn, translates into the loss of contrast, which is defined as the differences between one extreme—for example, brightness or hues—and another.

You can achieve the most basic form of soft focus through a halfway type of defocusing. Make two exposures on the same frame, dividing the exposure between them, and have one shot in-focus and the second slightly out-of-focus. An alternative is to use a soft-focus lens. These optics take advantage of a common *lens aberration,* or deficiency, in which not all the rays entering the lens are focused on the film plane. These out-of-focus rays soften the image, similar to the way defocusing does. This is also referred to as *spherical aberration* and is corrected for in all modern lenses except, of course, soft-focus lenses.

By far the most common approach to a soft-focus or diffusion effect is to use a filter to disrupt the focusing of light rays. Just about any material that isn't optically clear when placed over a lens will accomplish this, as will fogging the lens with your breath. In the case of soft-focus filters various substances are placed in the filter, or patterns, such as bubbles, stipples, and raised concentric circles, are placed on its surface. In all instances some of the rays hit these structures, causing them to *refract,* or bend, and preventing them from focusing on the film plane.

One group of soft-focus/diffusion filters is different: *net* and *black-dot filters.* Such companies as Tiffen, Inc., market a whole array of filters in which mesh or netting has been placed in a variety of patterns, densities, and colors. Soft-focus net filters are based on one of the most time-honored methods in portrait photography: stretching a piece of silk stocking over the lens to flatter the subject. And black-dot arrangements are just that: filters with very small black dots or blots scattered throughout them, offered exclusively by Harrison and Harrison.

Diffusion filters that block light rays from focusing correctly are available in two basic forms. These are the black-net type, such as the square Cromatek filter and the two Tiffen softnet filters (top), and the unique Harrison and Harrison black-dot filters (bottom).

Black-net and black-dot filters are capable of producing very subtle reductions in the fine details of a subject's skin texture while maintaining a good level of sharpness. The appealing result is apparent in this enlarged portrait, which I made with a Tiffen Black Softnet 3 filter.

Some manufacturers claim that both the net and the dot configurations break up the tiny detail of a portrait that often contains blemishes and facial lines, while retaining overall sharpness and contrast with only a minimal loss of light. Some people argue that this is just another form of refraction. One view suggests that some rays are blocked (or absorbed) by the black materials, just enough to eliminate the smallest detail. Another view maintains that these are just other forms of refracting materials.

Still another type of diffusion-filter design is the unique Portrayer by Minolta, which comes in two forms. The "S" filter uses a surface-refraction mechanism similar to other diffusion types, and the very interesting "P" filter claims to be the first one that uses "primary-selective diffusion." In other words, the P types use very weak, primary-color filtration to suppress the color of facial blemishes. These come in three strengths and don't rely on customary diffusion.

Over the years I've tested many filters using a system that combines objective and subjective methods, in keeping with the adage that photography is part science and part art. This approach tells me how much or what type of an effect a filter has (see Figure 5-6). I haven't made any attempt to rank the filters from best to worst since each photographer has his or her own reasons and purposes for using soft-focus or diffusion filters.

USING NONCHROMATIC FILTERS IN THE DARKROOM

Most nonchromatic filters can't be used effectively for darkroom work. Although very light ND grads can be used to hold back light during dodging, this is better handled by more conventional methods, such as cutouts or light cards. There may be times when the light of your enlarger is so intense that a weak, full-field ND filter over the lens can help.

Using diffusion filters to soften printed images in the darkroom, however, is a popular and effective practice. As with camera usage, you have to decide what effect is appropriate. Net and dot designs repress tiny detail, while stronger filters produce a variety of softer, defocusing effects with some important differences. Because you're focusing so close and using moderate to small apertures, the actual pattern of the filter may show itself as a secondary image in the picture. I've experienced this with Softar filters. The solution is to move the filter up and down during exposure.

Most times you'll want to use the filter for only a portion of the exposure in order to ensure a reasonably sharp image. I limit the total time by 20 percent, 40 percent, or 60 percent. This requires you to experiment and make changes with each print. Portraits, for example, may generally take more diffusion than landscapes. Finally, remember that in all printing you're reversing the highlight effect of the filter. For example, in black-and-white printing the black shadow areas produce a *halo effect* around the white highlights; the opposite happens when a nonchromatic filter is used on the camera.

FIGURE 5-6.

Type/Grade*

B&W Soft Focus II

B&W Soft Image I

Cokin Diffuser #1 and #2

Cromatek Softnet Black #1

Cromatek Diffuser Moderate

Harrison and Harrison Diffuser D1/2, D1, D2, D3, D4, D5, D6, D7, D8, D9, D10***

Harrison and Harrison TS Black Dot TS-1, TS-2, TS-3, TS-4, TS-5

Hoya Diffuser #1

Hoya Duto #1

Hoya Softener A and B

Tiffen Softnet White Diffuser 1W, 2W, 3W

Zeiss Softar I and II

* For this comparison, I tested 60 filters by photographing a target containing various patches, a gray scale, and a lines/mm target, as well as a White Lightning 600 strobe, a 105mm Nikkor lens at $f/4.0$, and Fujichrome 100 film. I read the lines/mm under a 60-power microscope at both their center and edges. I objectively measured contrast against the unfiltered

COMPARISON TESTING OF SOFT-FOCUS AND DIFFUSION FILTERS

Description	Effect**
Concentric rings, about 4 to the cm, with each ring made up of many thinner rings	II = H (M), LC (M), V (S) or LS (E)
Very faint, small, perfect circles randomly placed	LC (S) or LS (M-E)
Fine, irregular pattern resembling water splattered on a waxed floor	1 = LC (VS) or LS (S); 2 = LC (S), H (VS) or LS (M)
Black fabric net in hex pattern, set about 6 hex patterns to a cm	LC (VS) or LS (S)
Very faint, water-droplet-like pattern	LC (VS) or LS (S)
Very tiny, orange-peel pattern that becomes more defined and dense with grade	D1 = LC (VS); D2 = LC (VS) or L (S-M); D3 = LC (M), H (S-M), V (VS), or LS (M); D4 = LC (M), H (M), V (M), or LS (M); D5 = LC (M), H (M-E), V (M-E), or LS (M).
Irregular-sized black blotches of increasing density with grade	TS-1 = LC (VS) or LS (S); TS-2 = LC (VS) or LS (S); TS-3 = LC (M), H (S), or LS (M); TS-4 = LC (M), H (M), V (S-M), or LS (M)
Well-defined, irregular pattern that resembles water splashed on a waxed floor	LC (M) or LS (E)
Concentric circles at 2mm intervals; circles appear irregular, especially at the edges	LC (VS) or LS (S)
Small, defined, and different-sized raised circles	A = LC (VS) or LS (S-M); B = LC (S-M), H (S-M), V (S), or LS (M)
White net pattern, similar to Tiffen Softnet Black Diffuser; 3 to 4 hex patterns per cm for 1W; 6 hex patterns per cm for 2W; 9 hex patterns per cm for 3W	1W = TK; 2W = LC (VS) or LS (S); or 3W = LC (VS) or LS (S) or LS (S)
Small, well-defined, raised circular bubbles of similar size with more bubbles in a denser pattern in the II grade	I = LC (VS) or LS (S-M); II = LC (S), H (VS), or LS (M)

target as slight, moderate, and extreme. I rated flare from light to dark areas (the halo effect) in a similar way. I also noted any veling that occurred. The actual patterns used in the construction of each filter was examined under a 15-power microscope.

** Abbreviations for type and degree of effect: H = halo shimmer around highlights, LC = loss of contrast, V = overall veiling of contrast,

LS = loss of sharpness, VS = very slight, S = slight, S-M = slight to moderate, M = moderate, M-E = moderate to extreme, and E = extreme. Also, if an effect isn't listed, there was no significant, observable change as measured against the control. Only those filter grades listed were tested.

*** D 1/2, D6, D7, D8, D9, and D-10 weren't tested.

Softar I

Softar II

Softar III

Pro Soft (Light)

Pro Soft (Medium) *Pro Soft (Heavy)*

Diffusion/soft-focus filters are most commonly used in portrait work. These transparencies, shot by photographer Tony Corbell of Hasselblad USA, demonstrate how effects sometimes vary between brands and filter strengths in subtle ways. These photographs have been enlarged to clearly show how each filter affects skin texture, which is so critical in portraits.

FIGURE 5-7. DIFFUSION/SOFT-FOCUS FILTERS: WHICH ONE FOR WHAT PURPOSE?

With probably 100 or more diffusion/soft-focus filters on the market to choose from, you'll find that making a selection is a complex task. Generally, soft-focus filters decrease the sharpness of an image, while diffusion filters might also lessen sharpness but are more likely to affect contrast by diffusing light from areas of higher to lower concentration.

The best way to use these filters is to first decide on the effect you want and then find the filter that will produce it. The series of categories listed below will help you isolate the different results, as well as provide some generalizations about possible choices.

TYPE	EFFECT
Category I	These filters mitigate minor details, such as very small skin pores, but preserve overall sharpness. Black-dot and black-net filters are the weakest soft-focus filters.
Category II	This group of filters takes the sharpness off the subject without producing an obvious soft look. Most weak and some medium-strength soft-focus filters are included here.
Category III	These filters give an image a pronounced softness that effectively eliminates all small details. Most medium-strength soft-focus filters belong in this category.
Category IV	This kind of filter produces either a noticeable halo effect around pinpoint light sources or a thin shimmer of rim light around very bright highlight areas. Very few filters seem to produce this effect without also producing Category III and V results, such as Tiffen Pro-Mist 1 and 2 filters or a combination of Nikon's Soft 1 and 2 filters.
Category V	These filters are characterized by a fog-like overlay with a significant reduction in contrast between shades of gray and a "desaturation" of colors. This group comprises most filters labeled fog, mist, and pastel, as well as most of the strong diffusion filters.

CREATIVE FILTER APPLICATIONS

Throughout the book, I've emphasized the corrective role between light and film that both chromatic and nonchromatic filters play in all forms of photography. In addition, I've included some examples of how filters can be used beyond their corrective role to create or enhance a particular effect. In this final chapter, I focus on using filters creatively in order to significantly change an image. To do this in any sort of organized way requires pointing out what the options are for creative effects. In general, these possibilities fall into three categories.

One option is to change the image from a correct balance of properly rendered colors to a picture in which color plays a role beyond being a part of the physical characteristics of a subject. This can range from introducing coloration to achieve either a warm or a cool mood, to working with strong chromatic filters to establish a graphic, high-contrast representation. Another possibility is to use diffusion/soft-focus filters to produce such noticeable effects as strong flare, overall diffusion, or very soft focus. Typically, these effects create the impression of an atmosphere in the photograph. Yet another option is to employ so-called special effect filters that utilize diffraction to introduce something that isn't in the original scene, such as a star pattern from a small light source or speed streaks.

It is important to understand from the outset that you can achieve most of these creative results via methods that you generally avoid when your primary goal in using filters is color correction. For example, you might use a very strong chromatic filter to make a single color dominate a scene instead of working to correct the balance among all the colors in the scene. Also, many creative effects are produced by the combination of filters—sometimes as many as three or four—to obtain an overall result. In short, the kinds of creative effects discussed in this chapter often require a willingness to try something extraordinary because they're based on a desire to produce something out of the ordinary. So the bottom line is that you must be willing to take chances and go beyond the filter manufacturers' recommended uses in order to produce something different.

The techniques covered here represent a cross-section of methods and applications that serve as an introduction to creative applications rather than as a complete treatment. In addition to the examples of these techniques shown here, others have already appeared as illustrations in preceding chapters. The idea is to show how extraordinary filter use can alter the basic visual elements of a scene, which should, I hope, stimulate your own experimentation. This chapter begins with a class of filters that haven't been examined yet—the so-called special-effect filters—then continues with the other applications mentioned, and ends with some important information concerning the care and storage of filters.

STARBURST AND DIFFRACTION-PRISM FILTERS

This group of filters depends on the presence of a small or pinpoint light source in order to produce their individual effects. *Starburst filters* and their variants, *cross-star filters,* have lines running through the clear glass or resin; this causes a starburst or the longer cross-star lines to radiate out from the light source. These

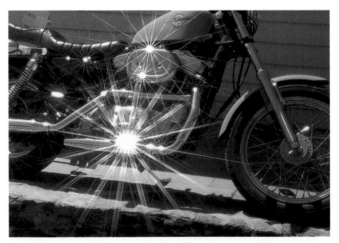

Filters that use diffraction to produce star patterns require pinpoint light sources or strong reflections. For this shot of a motorcycle, I used a Cokin Starburst filter to obtain the star pattern on the chrome work.

filters are used quite often in television productions of stage shows and are frequently employed in night shots. In both cases there are many small light sources or mirror reflections, as in the sequins on a singer's gown. The number of starbursts and cross stars depends on the filters' design. The stronger the light source, the larger and brighter the effects. Most strong reflections, such as the metallic sheen of a car in daylight, produce the same effects as light sources.

Not surprisingly, the additive primaries (red, green, and blue) occasionally appear when these filters are used with strong light sources. Furthermore, manufacturers have come up with all kinds of *diffraction-prism designs* that radiate the primary colors in wheels, fans, and circular starbursts. Filter quality is a factor in how much *flare* accompanies all of these effects. This causes a loss in contrast, which isn't always a bad idea in such high-contrast situations. Nevertheless, flare does tend to be critical with starburst filters in, for example, stage shots, although better quality filters have this well under control.

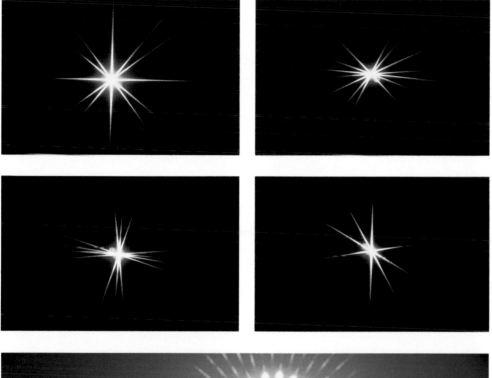

Most star filters produce a symmetrical star effect or circular patterns, such as the halo prism made by the Cromatek filter (below). Lee Filters makes a series of filters in which the star patterns are carved in only certain areas of the filter, so the photographer can control where the star effects will occur. Tiffen's Hollywood FX line of filters offers a unique series of individually handcut star patterns: North Star (top left), Hollywood Star (top right), Hyper (bottom left), and Vector Star (bottom right). (Courtesy of Tiffen Manufacturing)

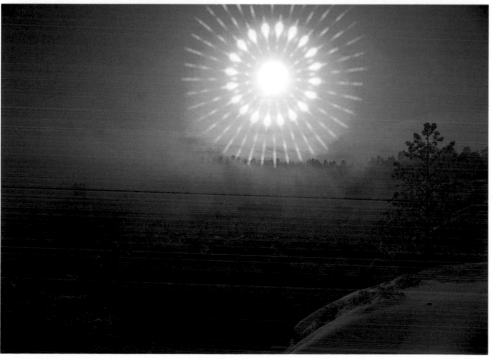

MULTIPLE-PRISM AND STREAK FILTERS

Multiple-prism filters, as the name implies, deliver several repeated images in any number of patterns. Take a look at The Repeater by Cokin. The arrangement of these multiple images comes from the manufacturer cutting a facet into the flat surface of a thick filter, causing an iteration of the scene in a circular or triangular pattern, as well as parallel repetitions from the center to the edge. Yet the image remains clear and undistorted. Faces, flowers, cars, and other quickly recognizable subjects are the best choices for this treatment.

A variation of this design is the *streak,* or *speed, filter,* which imitates the blur effect of a moving object. Here, the facets are prism-like and produce an elongation of the repeated image, blurring them into a streak. Still another type of filter gives the impression that you've zoomed in on a subject using a slow shutter speed, causing "zoom streaks" to shoot inward toward the center of the picture. Naturally this filter is called a *radial-zoom filter.*

A streak filter was used for this montage of magazine car clippings (bottom), and a radial zoom filter for another equally effective montage (top).

I used a Cokin speed filter and a Tiffen 0.6 graduated neutral-density filter in the upper half of this studio shot.

MASK, MULTIPLE-EXPOSURE, AND CENTER-SPOT FILTERS

These filters utilize different designs to shade the edge portions of the picture for some visual purpose. *Mask filters,* made out of opaque material, produce a distinct shape, such as a keyhole or a heart. They surround a portrait subject and are very popular for weddings.

Multiple-exposure/mask filters enable you to split the photograph into two parts, each exposed separately, in such a way that the final image shows no evidence of the two-shot sequence. This makes the subject appear twice in the picture. The filter consists of a bracket with a removable mask that covers exactly one half of the viewing area at a time. To use it, set your camera on a tripod and compose the shot through the open part of the frame. Then determine exposure as you usually do, but set your camera for a double exposure. Take the first shot with the mask in place halfway across the field of view. Now put the mask on the other side of the bracket, being careful not to move the camera, and take the second picture, again at the indicated exposure.

Center-spot filters come in many variations and are intended to lighten or apply diffused color around a center of interest, such as a face in a portrait setting. All of these filters have a clear center and a periphery covered with a diffusion finish, colored material, or patterns. The idea is to produce a diffused or colored vignette, again for the purpose of framing, but with a more dreamlike quality.

Multiple-exposure and mask filters work on the principle of exposing only half of the frame at a time by blocking part of the field. While photographing this young actress wearing a black dress, I first blocked the right side of the frame with a Cokin multiple-exposure mask. Then she changed into a blue dress, and I shifted the mask to the left side of the frame and made a second exposure in order to produce this effect.

One of the easiest ways to create a dramatic effect is to use strong chromatic conversion filters to reinforce a mood. For this landscape shot, I used an 80A filter and tungsten film to convey the cold of the snow scene.

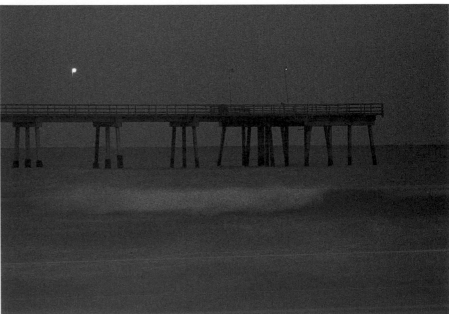

doesn't seem to work as well in general outdoor scenes because the blue coloration is too weak to overcome other colors illuminated by the bright sun. Keep in mind, though, that under such conditions a few subjects, including metallic structures, such as a steel-faced building, and subjects with cool colors, lend themselves to this effect.

You can obtain a hot-mood effect that is comparable in intensity to the blue-mood version. Simply combine an 85B filter and daylight film and then slightly underexposing the film in any form of daylight. Here again, you can produce a doubling effect by using this combination around sunrise and sunset when the light already has a strong, warm content.

At the extreme of the color-mood applications is the use of filters ordinarily reserved for work with black-and-white films. With a strong filter, such as a 23 red, 25 red, or 47 blue filter, almost all other colors will be blocked, with the exception of the filter's own color. The resulting picture will be rendered more like a single-color line drawing rather than a continuous-tone photograph. So it is important to choose a subject with strong black lines, such as in a steel-and-glass building or a well-defined silhouette.

When you shoot black-and-white films, you can use the moderately strong chromatic filters—the 21 orange, 58 green, and 12 yellow filters—to add graphic colors to silhouettes, particularly around sunset. At this time of day red, orange, and yellow filters work best; green filters are usually reserved for boosting the green color of grass, bushes, or a lush green setting within a forest. Also, don't forget that the strong CC filters are suitable for this monochromatic approach, too.

Overall, using diffusion/soft-focus filters with color films follows the same guidelines discussed above for

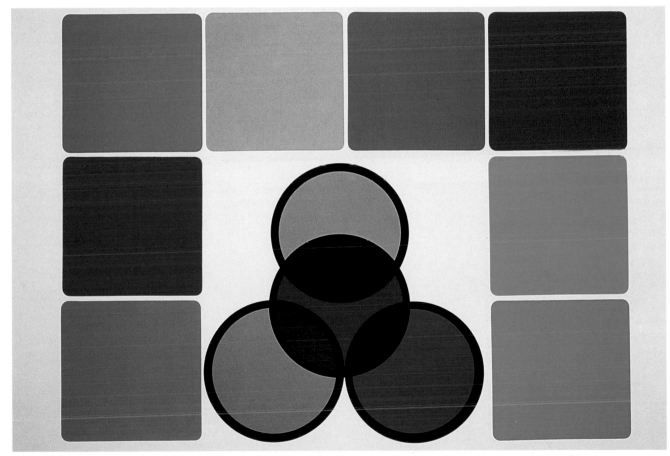

One of the most interesting of the strong, special-effects filters is the combination of a polarizer and a variable chromatic filter, which are sealed into the same retaining ring. When the polarizer is rotated the color changes, as using the Spiratone Color Flow and two polarizers set at different rotations shows. In addition, filter makers also offer kits of very bright, strong square color gels. These eight colors are included in the Cokin Creative Filter Kit.

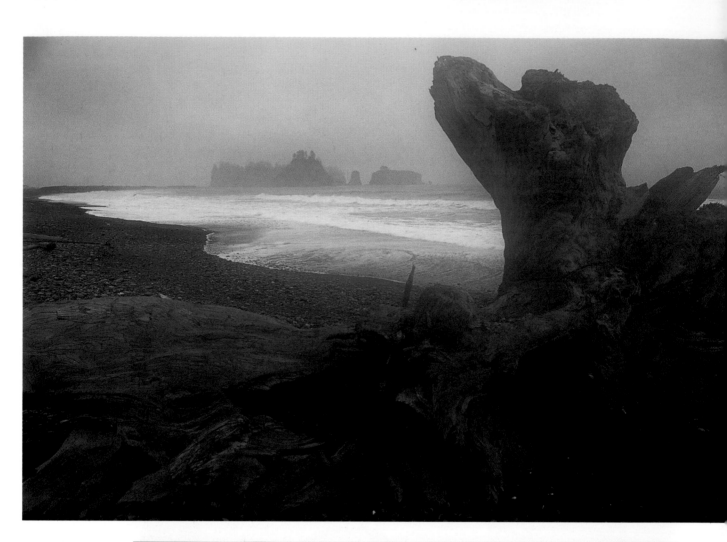

Creating a sense of atmosphere in a particular setting is often a matter of combining a strong warming filter, such as the 81EF, with a weak fog filter, as shown in this seascape (top). Another option is to use a strong soft-focus filter like the Tiffen FX5 with a 81D warming filter, the approach I used for the picture of the forest (bottom).

black-and-white film. But one notable difference exists. You can also add a weak color filter to the mix, thereby producing a mood or atmosphere through a lighter coloration. This works particularly well with warming filters. In general, the strong 81 series—the 81C, 81D, and 81EF filters—work better if you're trying to establish a distinct, warm atmospheric effect as opposed to just slightly warming up the subject. Tiffen's Hollywood FX line of warm diffusion/soft-focus filters, which are the Warm Soft FX, Warm Pro-Mist, and Warm Black-Pro Mist filters, have Tiffen's

812 warming filter built-in. Also of special interest are the new warm polarizers, which deliver blue skies with warmed-up subject matter all in one filter.

You can also employ some of the CC filter colors for their particular colorations and then add a misty, soft-focus rendering (review the top picture on page 24). The magenta and red series seem to work especially well this way at sunset. The combination of the yellow-series filters and diffusion/soft-focus filters tends to be more helpful when you shoot in bright sun to enhance an obviously warm setting with a diffused atmosphere.

I photographed this hotel several times, varying a Spiratone Color Flow Polarizer. The different color effects are the result of rotating the polarizing ring.

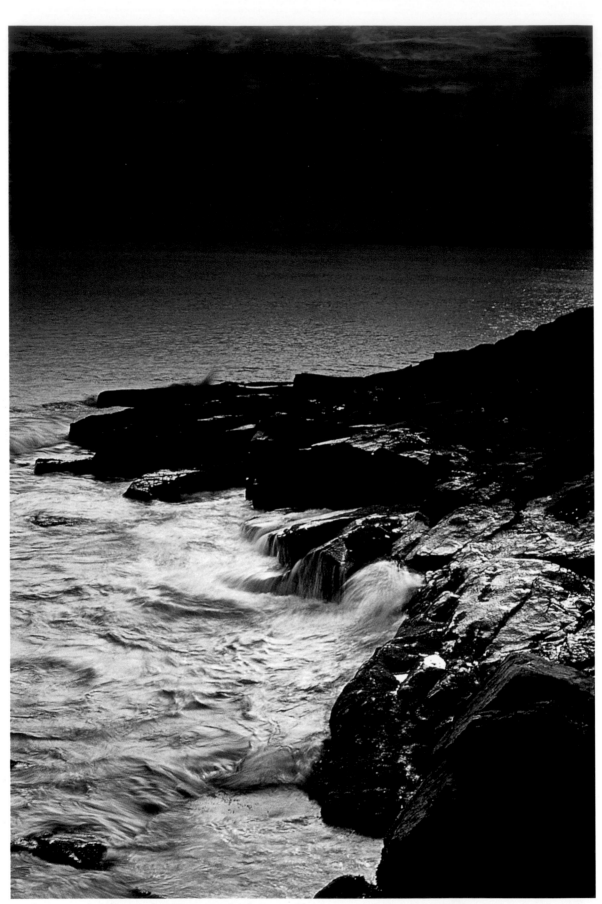

High-contrast lighting in a landscape can be dramatic, but it can also lack color. For this scene, I used a graduated tobacco filter on the sky to introduce color, along with a 0.6 ND filter on the foreground to help reduce the contrast. Then I added an 80A filter to preserve the blue in the water.

This stark scene benefited from the combination of a CC20 red filter and a Cokin graduated tobacco filter.

Creative filter effects aren't limited to a single filter but very often rely on combining the effects of several filters to achieve a desired final result. For this shot of California's Golden Gate Bridge, I used a polarizer, a CC40 magenta filter, and a Nikon Soft 1 filter.

CARE AND STORAGE OF FILTERS

Handle all of your photographic filters very carefully. This is especially true of gel filters. But no matter how careful you are, these filters always seem to scratch and need to be replaced. Even when mounted in their own holders for bracket-type systems, gel filters don't hold up under continuous use. The only recommended way to clean them is with a dry brush or an aerosol. You can, however, clean glass and plastic-resin filters with a photographic-lens cleaner and lens tissue, just as you do your lenses. It is really important, however, to put the fluid on the tissue not the filter when cleaning filters since you run the risk, with some circular mounts, of loosening the cement. I've also had good luck with the newer photo cloths that allow you to wipe off minor smudges, but again this is only for glass and plastic-resin filters.

I've accumulated more than 300 filters over a lifetime of use. Keeping them all properly stored in their various configurations for quick retrieval has been a challenge. But the real storage problem comes when you shoot in the field and have to use many different designs on an assortment of lenses for cameras of varying formats. I've seen and tried a large number of storage boxes and envelope-type carriers, some quite successfully. But over the years, I've slowly been standardizing on a 72mm mount for all lenses and circular filters, except for my panoramic photography. I do this with step-up rings on the lenses with smaller tread sizes. This means I have to carry only one size bracket for my rectangular resin and glass filters. The 72mm circular ones are all screwed together, with both ends sealed with a set of *stack caps*. (The only remaining source for these, by the way, is the Filter Connection in Wilton, Connecticut.) So I'm able to carry between 10 and 15 circular glass and resin filters in a compact stack, storing my rectangular designs, including gels, in their own separate holders. All of these accessories fit in a small fanny pack that I wear in front, or in two side pockets of my camera bag.

These are some of the items you need for proper maintenance of your filters, including lens cleaning papers and solutions.

As you can see, there are many ways to store and carry filters other than the single-filter compartments that manufacturers supply. Several pouch arrangements that hold all filter designs are available. For example, you might choose Domke's 9-insert, fold-up model (center) or Sailwind's larger, cushioned pouches (top left). Another option is to try Cokin's small, slotted, plastic boxes that hold 10 of the company's square or circular filters (right). You can also get a set of stack caps that seal off the end of several filters, which are screwed together, like the 72mm and 52mm models shown here (bottom left).

One final note about filter care: Always protect filters from the elements. When shooting with a tripod and waiting for a sunset or sunrise, particularly in fog or at the shore, I always cover my camera with a waterproof, opaque cover. Other culprits are sustained heat, humidity, and sunlight, which eventually affect the dyes in chromatic filters.

Throughout this book I've emphasized a systematic method to using filters rather than the more common piecemeal approach. I've always maintained that increased knowledge about what's going on causes you, in turn, to recognize opportunities for creative as well as controlled use of filtration. The bottom line here is "nothing ventured, nothing gained," no matter how much knowledge you accumulate. This means that you have to be willing to experiment, or at the very least, put the theory into practice. Of course, I have to acknowledge we are creatures of habit and are resistant to changing some of our established ways of thinking.

For me, using filters successfully has gone beyond implementing guidelines because I've always been curious. I want to know "what would happen if" In other words, I like to take chances. This doesn't mean throwing procedures to the wind and just slapping on the filters spontaneously. Yes, I've done this, scoring an occasional hit that then drove me crazy because I couldn't remember which filter I used and how, or why I got a particular effect when I did know what I used. There were enough of those experiences to stir my curiosity even more and to convince me to come up with a more systematic approach, much of which has formed the basis of this book. I learned a good portion of this from other photographers and from thinking about the theory behind the phenomenon. It also helps a great deal to have filters always handy for use by making them part of your standard equipment, so that when you say "what if" finding out is just a matter of reaching into your camera bag and experimenting.